The Shoes
of Van Gogh

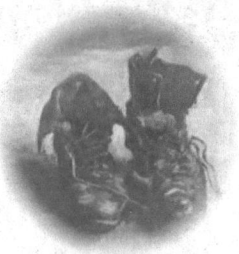

Vincent van Gogh, self-portrait

THE SHOES OF VAN GOGH

A Spiritual and Artistic Journey to the Ordinary

CLIFF EDWARDS

A *Crossroad* Book
The Crossroad Publishing Company
New York

To the faculty and students of
Virginia Commonwealth University's new
SCHOOL OF WORLD STUDIES.
With courage and good humor, this adventurous community has overcome gigantic obstacles, shared a vision for the future, and celebrated together the pleasures of learning and teaching in difficult and perplexing times.

The Crossroad Publishing Company
www.crossroadpublishing.com

Copyright © 2004 by Cliff Edwards

All rights reserved. No part of this book may be reproduced, stored in a retrieval system, or transmitted, in any form or by any means, electronic, mechanical, photocopying, recording, or otherwise, without the written permission of The Crossroad Publishing Company.

Passages from the letters of Vincent van Gogh are reprinted by permission of the Vincent van Gogh Foundation, National Museum Vincent van Gogh, Amsterdam.

Emily Dickinson's poems "My cocoon tightens — colors tease" (1107) and "By homely gifts and hindered words" (1611) are reprinted by permission of the publishers and the Trustees of Amherst College from *The Poems of Emily Dickinson*, Ralph W. Franklin, ed., Cambridge, Mass.: The Belknap Press of Harvard University Press, copyright 1998 by the President and Fellows of Harvard College. Copyright 1951, 1955, 1979 by the President and Fellows of Harvard College.

The text is set in 12/15.5 Goudy Old Style. The display type is Goudy Old Style and Goudy Handtooled.

Printed in the United States of America

Cataloging-in-Publication Data for this title is available from the Library of Congress
ISBN 0-8245-2142-0
ISBN 978-0-8245-2142-4

Contents

Foreword	vii
Preface	xii
Acknowledgments	xv
One The Eye with Which I See God	1
Two Henri Nouwen and the Abbey	6
Three Vincent's Conversion to Painting	17
Four The Birth of God: Vincent and the Cradle	28
Five The Mystery of His Father's Bible	37
Six Empty Shoes: A Ghost Story	49
Seven Blossoming Trees and Butterflies	58

Eight
Vincent's Bedroom: A Painting of Nothing at All 67

Nine
La Berceuse: The Mystery of the Missing Cradle 81

Ten
Starry Sky: Splendors of the Night 90

Eleven
First Steps: A Family Sacrament 102

Twelve
Wheatfield with Crows: A Harvest Hymn 113

Thirteen
The Eye with Which God Sees Me 134

Chronology of Nine Van Gogh Works:
Drawing and Paintings Discussed in Chapters 4
through 12 142

Appendix
Illustrations 144

Notes 147

Index 153

Foreword

Crossroad first came into contact with Cliff Edwards through his academic book Van Gogh and God: A Creative Spiritual Quest. *So compelling were Edwards' insights that we were delighted to hear from the Henri Nouwen Literary Centre about a new, more devotional and intimate work Edwards was writing. Because of the similarity in theme between the two books, the role the Nouwen Centre played in bringing Crossroad and the author together, and the fact that the author and the spiritual tenor of this new book are indebted to Nouwen, here we reprint the foreword Nouwen wrote for that earlier book.*

Cliff Edwards' *Van Gogh and God* is the book I have been eagerly awaiting. After all these decades of van Gogh studies, finally someone opens up for us Vincent's deepest quest and convincingly shows that the art of the "sorrowful, yet always rejoicing" Dutch painter is of deep theological and spiritual significance. Cliff Edwards radically dispels the view that Vincent was lost in religious fanaticism until he found his true vocation as a painter. He clearly demonstrates that the whole of Vincent's life and work is a rich source for all those who search for a deeper knowledge of God.

This book brings back to me very precious memories. While on the faculty of Yale Divinity School, I taught several seminars on "The Ministry of Vincent van Gogh." There is no doubt in my mind that these seminars had a much more profound effect on my students than any other seminar or course I taught. I have used many spiritual writers, especially the contemporary writer Thomas Merton, as useful guides, but I have never found students to be more personally, intellectually, and emotionally involved than they were during periods of attentive looking at Vincent's drawings and paintings. I still remember how we would spend long hours together in silence, simply gazing at the slides of Vincent's work. I did not try to explain much or analyze much. I simply wanted the students to have a direct experience of the ecstasy and the agony of this painter who shared his desperate search for meaning. After such seminars it seemed that we all had been touched in places that no spiritual writer had been able to reach. A similar effect resulted from the readings of Vincent's letters. Their haunting, passionate expression of longing for a God who is tangible and alive, who truly comforts and consoles, and who truly cares for the poor and the suffering brought us in touch with the deepest yearnings of our soul. Vincent's God, so real, so direct, so visible in nature and people, so intensely compassionate, so weak and vulnerable, and so radically loving, was a God we all wanted to come close to.

The van Gogh seminar was born out of my own feeling of affinity with Vincent and his work. Few writers

or painters have influenced me as much as Vincent. This deeply wounded and immensely gifted Dutchman brought me in touch with my own brokenness and talents in ways nobody else could. The hours spent walking through the Kröller-Müller Museum in the Netherlands and the days spent reading his letters were personal times of restoration and renewal. They were times of solitude in which a voice spoke that I could listen to. I experienced connections between Vincent's struggle and my own, and realized more and more that Vincent was becoming my wounded healer. He painted what I had not before dared to look at; he questioned what I had not before dared to speak about; and he entered into spaces of the heart that I had not before dared to come close to. By doing so he brought me in touch with many of my fears and gave me the courage to go further and deeper in my search for a God who loves.

And now here is the book: *Van Gogh and God*. It almost seems that Cliff Edwards, in his careful and sensitive study of Vincent's spiritual journey, is telling me that I was not crazy after all when I spoke of Vincent as one of the main spiritual guides in my life and when I invited students to discover him as a true source of theological reflection.

I have always felt uncomfortable with the many psychological and psychoanalytical interpretations of van Gogh's work. Although they opened my eyes to the significant connections between Vincent's personal life and the way he expresses himself in his drawings and paintings, I always sensed that there was something to

be said and understood that went far beyond the level of psychodynamics. It is Cliff Edwards' great contribution that he has helped us to better understand the spirituality of van Gogh. With remarkable lucidity, he shows how deeply Vincent's spirituality was molded by the Zen Buddhist as well as by the Christian tradition; the best of the Japanese as well as the Dutch spiritual heritage were being lived and expressed by Vincent in word and picture. Most original is Edwards' perspective on the "Oriental connection" in Vincent's work. The nonhuman-centered way of Zen Buddhism brings us close to Vincent's approach to nature and helps us to understand why Vincent saw health and restorative forces where we are inclined to see only violence, chaos, and approaching death.

Cliff Edwards' astute understanding of Zen Buddhism, as well as of Christianity, has allowed him to portray Vincent as one of the most significant spiritual figures of the nineteenth century — an artist who fully deserves the attention of modern theologians interested in the interreligious dialogue.

After reading *Van Gogh and God*, I understand much better why Vincent had such a deep effect on me and countless people. Cliff Edwards' study makes it clear that Vincent wants not only to lead us to a new way of seeing but also to a new way of living. He invites us through his art to a change of heart. Vincent always remained a minister and for that reason in front of his drawings and paintings we experience a call to conversion.

That most likely is the deepest reason for his universal appeal.

I am deeply grateful that *Van Gogh and God* has been written. and I am convinced that those who read it will find in Vincent a lasting spiritual companion.

<div style="text-align: right;">HENRI J. M. NOUWEN</div>

Preface

Vincent van Gogh changed the direction of art. In Picasso's words:

> Beginning with Van Gogh, however great we may be, we are all, in a measure, self-taught — you might almost say primitive painters. Painters no longer live with a tradition and so each of us must create an entire language. As soon as we saw that the collective adventure was a lost cause, each one of us had to find an individual adventure. And the individual adventure always goes back to the one which is the archetype of our times: that is, Van Gogh's — an essentially solitary and tragic adventure.[1]

But theologians and religionists have yet to extend Picasso's insight to include Vincent's discoveries in the art of the spirit. They have been slow to see that he provides theological challenges: in religion as well as in art, Vincent opened a path on which each seeker must struggle in the face of the great mystery that he called "something from on high" and "something that wells up from within."[2] Vincent's way of the spirit relied on personal experience rather than institutional traditions. He joined with his brother, Theo, in a community of two

Preface xiii

and never lost faith in their shared sacrifices for creative discovery in the art of living.

This book cannot provide an easy self-realization plan, with six or twelve steps to a happier life. Vincent provided no keys to success and attached few morals to his life story. But through his words and images, we will meet a different kind of spiritual master, one who struggles, fails, is caged and confused, experiments, overcomes obstacles, abandons old hopes, and finds new possibilities.

In Henri Nouwen's words, Vincent van Gogh was a "wounded healer" who expected our heartfelt participation in his struggle, a response to the "soul" he put into his letters, his drawings, and his paintings. Vincent's creations draw us in so that we become not simply observers of his work, but companions on his path.

Our journey takes us through two bodies of his images, those in his letters to Theo, his family members, and a small circle of artists, and those in his drawings and paintings. They will challenge and comfort you on your own spiritual quest.

Quotations from Vincent's letters are from the most accessible collection, the three volumes of *The Complete Letters of Vincent van Gogh* (Boston: New York Graphic Society, 1981), which is found in many libraries and is available in a boxed edition. Black-and-white images of drawings, sketches, and a few paintings are reproduced here, but reproductions of the paintings in wonderful color and detail can be found in many volumes of Vincent's work. Any large bookstore or library

has a selection.³ Museums like the Metropolitan Museum of Art in New York, the Boston Museum of Fine Arts, the Art Institute of Chicago, and the Fogg Art Museum at Harvard all have small collections of Vincent's work. The Rijksmuseum Vincent van Gogh in Amsterdam will bring you face to face with the largest collection in the world — the collection Theo, his wife, Johanna, and their son, Vincent's godson, preserved for us. Not far outside Amsterdam, in a beautiful sculpture park at the town of Otterlo, is the second largest collection of van Gogh's works. Seeing one of Vincent's paintings is a memorable experience; copies, no matter how large or carefully done, cannot substitute for the originals. Meeting one of Vincent's original paintings may well be the occasion when his spiritual influence touches your life most strongly. Having a good print of a favorite work you can "converse" with daily is also inspiring.

Vincent's advice would be to make a serious and sacrificial art of your own life. He would almost certainly advise you to take seriously the prophetic art of the struggling artists of your own time, and to support and encourage their efforts to express heart and soul to a world in need of vision and comfort.

Acknowledgments

This volume sails to you on an ocean of gratitude.

I am grateful to family and friends for the mix of peace and stimulation that has allowed me a life of thinking and reading, travel and research, teaching and writing.

I am thankful to each and every one of the faculty, staff, and students of Virginia Commonwealth University's Program in Religious Studies for the community of creative discovery and happy celebration they have nurtured. Without the support it offered day by day, I could not have researched and written this book, and would have missed out on a good bit of fun as well.

I thank museums from the Virginia Museum of Fine Arts, to the National Gallery in Washington, to the Metropolitan Museum of Art in New York, to the Rijksmuseum Vincent Van Gogh in Amsterdam for the surprises they house and the vision they have offered. Over many months, Marije Wissink at the Van Gogh Museum has patiently answered my questions and arranged for my use of Vincent's letters and paintings. I am deeply indebted to her and the staff of the Rijksmuseum Vincent van Gogh.

My gratitude to the Coolidge Endowment and Cross-Currents for a summer in New York City that gave

me daily access to the Metropolitan Museum of Art, a stimulating company of Coolidge Scholars, and the opportunity to test the ideas I was developing for this book.

My thanks to Gwendolin Herder at Crossroad Publishing Company, who read my rough manuscript and first saw its possibilities, to Maria Devitt, who has thoughtfully guided me through each step of the way toward publication, and to Matthew Laughlin, who has so professionally overseen the entire production process.

I am thankful to Sue Mosteller, director of the Henri Nouwen Literary Centre at L'Arche Daybreak, and to Catherine Kapikian, director of the Henry Luce III Center for the Arts and Religion at Wesley Seminary, for their encouragement in this project. My thanks to Marcia Powell, who worked through the French correspondence of Vincent van Gogh with me many years ago and has keep watch over my writing ever since. My gratitude to Brother Toby McCarroll of Starcross Community, to Sam Forrest of Buddha Ranch, and to David Cain of Mary Washington University for creative conversations that have enriched this work. Suzanne Hoeferkamp's scholarly contributions in religion and art have been in my mind throughout my writing, and the work of Frederick Franck at Pacem in Terris has been an inspiration over many decades.

ONE

The Eye with Which I See God

A window allows us to see a world beyond our limited space. It is a miracle that allows us to see through a wall. Imagine walking along a wall that blocks your field of vision and then coming upon a window through which you see meadows and mountains. But there is more. A window is a double miracle. It not only allows us to see out; it also invites light in to illuminate our interior space. A window makes visible the world without and the world within.

Paintings are windows. They allow us to see meadows and mountains in spite of restrictive walls and allow light into the darkest corners of the soul.

The great philosopher-theologian Paul Tillich said it this way in his book *Dynamics of Faith:*

> All arts create symbols for a level of reality which cannot be reached in any other way. A picture and a poem reveal elements of reality which cannot be approached scientifically. In the creative work of art we encounter reality in a dimension which is closed to us without such works.[4]

The symbolic power of art "not only opens dimensions and elements of reality which otherwise would remain unapproachable but also unlocks dimensions and elements of our soul which correspond to the dimensions of reality."[5] We might then say that paintings are unique windows on the world and windows into the soul. If it were not for such windows, there would be dimensions without and within that are lost to us.

When Vincent van Gogh committed himself to an asylum in May 1889 after a frightening attack — an episode of epilepsy according to the doctors of his day — he was confined to a cell. He described what he saw through his window in a letter to his brother Theo:

> Through the iron-barred window I see a square field of wheat in an enclosure, a perspective like Van Goyen, above which I see the morning sun rising in all its glory. (Letter 592)

Van Gogh likened what he saw to a painting he remembered. After a night in darkness he went to that same barred window again at dawn:

> This morning I saw the country from my window a long time before sunrise, with nothing but the morning star, which looked very big. Daubigny and Rousseau have done just that, expressing all that it has of intimacy, all that vast peace and majesty, but at the same time adding a feeling so individual, so heart-breaking. I have no aversion to that sort of emotion. (Letter 593)

Van Gogh himself associated windows and paintings. He knew the power of paintings to permeate the scene from a window with deep emotions, opening the soul of the artist and of the viewer. This went far beyond the individual artist and his skill. As he wrote to his Dutch friend Anthon van Rappard:

> Art is something which, although produced by human hands, is not created by these hands alone, but something which wells up from a deeper source in our souls. (Letter R43)

To Vincent, the profundity of a creative work of art permeates the world with "deep emotion" and expresses a source that carries us beyond the human sphere.

In the Van Gogh Museum in Amsterdam over a dozen "windows" open along a wall. In one there is an orchard in full bloom, in another, ripened sunflowers in a vase; nearby a wheatfield is ready for harvest. Another "window" shows a view of Vincent van Gogh's bedroom in his beloved Yellow House in Arles. On his bedroom wall are portraits he painted of two of his friends. His blue work jacket hangs on a peg on the wall. We know that Vincent was forced to leave his bedroom and his Yellow House over a century ago, and that house was demolished in a bombing raid in World War II. The paintings, however, have the power to continue to invite viewers to share moments of enlightenment that have been transformed into art.

The German mystic Meister Eckhart, a Dominican of the 1300s, left us a much-quoted statement that has puzzled readers over the centuries:

> The same eye with which I see God
> is the eye with which God sees me.[6]

Imagine an artist stopped dead in his tracks by a particular scene at a particular moment, not unlike Moses turning aside to see the burning bush. The artist loses consciousness of himself. His painting of the scene seems to take form as a gift from beyond. The painting is the eye with which the artist sees into the life of God, and it is also the eye through which God sees into the life of the artist. Vincent wrote:

> I have a terrible lucidity at moments, these days when nature is so beautiful. I am not conscious of myself anymore, and the picture comes to me as in a dream. (Letter 543)

The eye of the artist receives a revelation, an expression of the divine in the ordinary. His eye sees creation and with it the action of the Creator. The artist paints, and opens his soul in that painting, and through it God sheds light on his interior life.

When I view that painting, I am invited to participate in the artist's moment of revelation. The painting is offered to me as the eye with which I, too, can see God as the artist did. I am called to open my soul in meditative attention to the painting. The painting becomes for me the eye with which God sees into the depths of my soul and shows that depth to me. Meister Eckhart's puzzle is not so difficult after all when we think of paintings as windows.

Vincent van Gogh can be experienced as spiritual guide through the windows on the world and the soul he offered to us in his drawings and paintings. Vincent's images are among the most recognized in the world, of phenomenal popularity with the public. Vincent's eye has taught astounding numbers of people to see the world, and to see into their own souls.

Vincent van Gogh as spiritual guide may raise serious questions for some. He cut off his ear, had mysterious attacks, and spent time in an asylum. Even admitting the popularity and power of his art, is he a proper choice for a spiritual guide? Henri Nouwen, priest and theologian, was known to millions through his books on spiritual direction, his courses at the divinity schools at Yale and Harvard, and his final work as chaplain in a community of people with disabilities at Daybreak in Toronto, Canada. Since his death in 1996, numerous collections of his writings, biographies, and studies of his influence have been added to the Nouwen literature.[7] He gave a resounding "Yes" to the question of whether Vincent van Gogh and his works are a rich source of spiritual guidance. In fact, van Gogh was Nouwen's personal spiritual guide.

TWO

Henri Nouwen and the Abbey

> To try to understand the real significance of what the great artists, the serious masters, tell us in their masterpieces, that leads to God; one man wrote it in a book; another, in a picture.
>
> (Van Gogh in Letter 133)

Vincent van Gogh has most often been viewed as a tortured, unhappy, mentally ill genius who created art out of the dark and painful abyss of his sickness. A dozen years ago I began a quest to bring to light quite another Vincent, one who was a thoughtful student of the Bible, a sensitive reader of Shakespeare, Dickens, Zola, Flaubert, Whitman, George Eliot, and Harriet Beecher Stowe, an artist who out of compassion sacrificed himself to fashion a new art of the spirit that would speak to ordinary people, bringing comfort and healing. I saw Vincent van Gogh as one of the significant spiritual figures of the nineteenth century, an artist who deserved the attention of theologians, church members, and spiritual pilgrims seriously seeking life's meaning and mission.

My own attempt and Henri Nouwen's enthusiasm about these very aspects of that artist from his homeland brought our paths together briefly. Years ago I moved through college and seminary, learned Greek and Hebrew, and focused on the study of the Bible. After earning a Ph.D. degree at Northwestern University, I taught religion courses in small colleges in the South, and finally at a large, urban state university, Virginia Commonwealth University in Virginia, where I still am today. It gradually became clear to me that growing student interest in Asian traditions required that I broaden my understanding of religion. A grant sent me to Japan for almost two years. There I found my way to Daitokuji, a Zen monastery in Kyoto, to learn Buddhism. Zen gardens, Zen ink paintings, Buddhist sculpture, and ukiyo-e woodblock prints attracted me and moved me. As I attempted to understand Asian religious art, I found that Western artists, particularly the Impressionists, had gone through that struggle before me. I visited the museums of Paris and marveled at the influence of Japanese art on Paul Gauguin, Edgar Degas, Mary Cassatt, Toulouse-Lautrec, and so many others. I went to the village of Giverny to view the Japanese gardens and lily pond Claude Monet had Japanese artisans create for him. In his Giverny home Monet hung scores of Japanese prints, and at his Japanese gardens and pond he spent the last years of his life doing a very "Japanese" thing, painting water lilies.[8]

My study of art then took me to Amsterdam, where I was surprised by two unusual paintings at the Van Gogh

Museum. I already knew both of those works from Japanese prints I had seen. Vincent van Gogh had copied in oils two of the woodcut prints of the famous Japanese artist Hiroshige. He had purposely set out to learn to see nature as the Japanese artists saw it. I turned to his letters and discovered how excited he and his brother Theo were as they collected Japanese prints at Bing's Art Nouveau shop on Montmartre.[9] Later, when Vincent moved to Provence in the south of France, he called that countryside of orchards and wheatfields his "Japan" and sought to "draw like the Japanese." In his enthusiasm, he went so far as to write to Theo, "All my work is founded on Japanese art" (Letters 510, 511).

Why had my work in theology mentioned numerous novelists, poets, and philosophers as sources for theological thought, but never mentioned either the paintings or the powerful letters of Vincent van Gogh?

But my discovery of Vincent's deep involvement with Japanese art is not what surprised me the most about his letters. I was astonished by the artist's knowledge of the Bible, the deep thought he had given to religious issues, his early resolve to become a Dutch Reformed pastor like his father and grandfather. I was shocked to learn how late he had come to painting. Art was a second choice after his attempts to become a pastor failed and he had been dismissed as a probationary evangelist

to Belgian miners. Vincent van Gogh's spiritual musings and his direction of his spiritual energy into painting during the last ten years of his life gripped me. Why had my work in theology mentioned numerous novelists, poets, and philosophers as sources for theological thought, but never mentioned either the paintings or the powerful letters of Vincent van Gogh?

A student in one of my university religion classes told me that she had taken theology classes at Yale Divinity School and worked as an assistant to Dr. Henri Nouwen in a course on van Gogh and theology. I had read several of Henri Nouwen's books and knew where to search, but could find no reference to van Gogh. What I did find was Dr. Nouwen's current address at a place called Daybreak in Toronto, Canada.[10] Apparently he had left his positions at Yale and Harvard to serve as a chaplain to a community of people with disabilities. With trepidation, I called him. His answering voice sounded weary and distracted, but when I described my interest in van Gogh's letters and their religious content, his voice became lively and excited. He said, "Yes, I wore out those three volumes of his letters. They literally came apart in my hands over the years." We found that we had several things in common. We had been born in the same year and ordained at the same time, he as a Roman Catholic priest, myself as a Methodist clergyman. We were both interested in the psychology of religion and had both taught courses in that subject. We talked about our favorite passages in the letters and our favorites among Vincent's drawings and paintings. He told me that of

all the theology and spirituality courses he had taught, the ones that meant the most to him were the seminars on van Gogh's spiritual search. He never found students more personally, intellectually, and emotionally involved than during those periods of attentive looking at Vincent's drawings and paintings.

Nouwen recalled the hours he had spent in the museums of the Netherlands viewing van Gogh's art as times of personal restoration and renewal. He felt a special affinity with that fellow Dutchman who sought a comforting and consoling God who cared for the poor and the suffering. Nouwen spoke of receiving courage for his own search through his experience of Vincent's search. He confessed that Vincent van Gogh had been one of the major spiritual guides in his life and work.

Why had Henri Nouwen never written about van Gogh? In *Seeds of Hope: A Henri Nouwen Reader*, one searches the sixteen pages of annotated bibliography in vain for any mention of him.[11] Could it be that Henri felt van Gogh's influence was too immense, too diffuse, too deep, or too personal for him to write about? I had saved my questions on that subject for a face-to-face meeting with Henri, a meeting we had talked about and had assumed would one day materialize. His sudden, unexpected death after a heart attack intervened.[12] I would never get to ask him.

Almost five years passed since Henri's death. I remembered a suggestion he had made in one of our last phone conversations. At the end of the call, he said to me, "I hope that someday you will go to the Abbey of the

Genesee in upstate New York, where I spent two memorable retreats of several months each. I am leaving my van Gogh books and papers there, and I want you to see them." I wrote to the abbot of the Abbey of the Genesee, John Eudes, the spiritual director whose presence led Nouwen to request permission for lengthy retreats there, where he worked as a monk among monks baking bread and gathering stones for the building of a new sanctuary. Henri told the story of that first stay at the Abbey in his book *The Genesee Diary: Report from a Trappist Monastery* (1976) and published a series of prayers from his second retreat there, *A Cry for Mercy: Prayers from the Genesee* (1981). Abbot John Eudes sent me an answering note:

> Dear Professor Edwards,
> Yes, we do have Henri's Van Gogh materials and you would be able to study them if you can manage to get here. Carry this note with you in case I am not at home when you come, show it to the Prior and he will see you are supplied with the materials and a quiet room in our gatehouse to study them. If, as I expect, I am home, just ask for me. The materials are the complete edition of Van Gogh's letters, 400 or more slides of his paintings, various other articles and books treating of his life and work.
>
> Abbot John Eudes
> Abbey of the Genesee
> Piffard, N.Y.

The summer of 2001 I was invited to join a group of Coolidge Fellows at Union Theological Seminary in

New York. What a wonderful place to be, with the memory of so many great theologians who had walked those seminary halls over the decades. Across Broadway was Columbia University, where John Cage the composer, members of the Beat Generation, and so many others had listened to lectures on Zen Buddhism by D. T. Suzuki; directly across the street from my dormitory was Corpus Christi Church, where Columbia student Thomas Merton was baptized on November 16, 1938.

I was in New York. Here was the perfect opportunity to see Henri Nouwen's collection of books and papers on van Gogh left at the Abbey. I soon understood Abbot Eudes's caveat. A bus down Broadway to the Port Authority Bus Terminal, and I was soon on a Greyhound bus bound toward Binghamton, Syracuse, and Rochester. Somewhere in Pennsylvania I was transferred to a Canadian bus. Hours later, as it grew dark, I arrived in the tiny bus station in Rochester. I was told the closest I could get to Piffard and the Abbey was a town called Geneseo, and there would be no bus there until the following morning. A night in the bus station, and an early morning bus took me to a beautiful small town without a car moving on its main street. In a coffee shop were three self-identified "old-timers" at coffee and conversation. "No," they told me, "there's no bus to Piffard. Piffard is just a sign on the road." While they debated whether it was more or less than a dozen miles to Piffard and the Abbey, I started my hike.

I am a good walker, and the quiet countryside with its stands of trees, green cornfields,and golden wheat-

Henri Nouwen and the Abbey

fields, was beautiful. The Abbey grew its own wheat to make "Monk's Bread," famous in the area. I thought of Henri Nouwen, working at the Abbey. Certainly he must have thought of scores of van Gogh drawings and paintings of wheatfields and the many passages in the letters that talked about them. From a wheatfield with a lark flying over it painted while he hiked the countryside around Paris to a walled-in wheatfield outside the asylum in Saint-Rémy, Vincent left us a record of the plowing, sowing, early green sprouts, and ripe golden harvest. Wheatfields became for him a symbol for human life and the location of "health and restorative forces" (Letter 649). Did Henri Nouwen respond to this and seek healing when he asked permission to spend months at that Abbey set among the wheatfields? Perhaps so.

Above the ripened wheat, I could see the roofs of buildings that must belong to the Abbey. I followed a long winding driveway past thistles, Queen Anne's Lace, and butterflies to what I guessed was the gatehouse. Beside it was a beautiful stone and timber sanctuary for which Henri Nouwen had helped gather stones. Gravel gardens, shaped shrubs, and even an old pond with a tiny island reminded me of the Daitokuji Zen monastery. I opened the heavy wooden door and entered a spacious sitting room with shelves of books. Through another doorway I could see a room with racks of bread. I rang a bell for the prior, showed him my note, and he told me to wait; he would get the abbot.

Abbot John Eudes was graying, with a stubbly beard, dressed in gray work trousers and a dark green polo shirt.

He extended his hand, smiled, and asked that I follow him. We moved through a confusing maze of corridors. Occasionally a monk appeared, wearing the black-and-white robes of the Trappists, smiling and bowing quietly to the abbot as we passed. As we walked through the refectory with its large bright windows, the abbot gestured toward the broad wooden tables: "These we made from our own timber." We entered the large, low sanctuary. It was dark, with narrow slits of windows made of colored glass, which gave a blue, red, green, and golden glow to the space. The walls were made of large, smooth stones gathered at a nearby river. Some of the stones were half our own height. The abbot paused and put his hand on one stone. "This one I gathered. That stone was one Henri helped find. The next one has bits of garnet in it." He was pleased with their beauty. As he looked at the wall of stones, he grinned: "We were lucky to find a stonemason from Italy who had once worked with stones in the Alps. He was an artist. Some days he would only select and place two stones. I was very nervous. I was paying him by the hour." He shook his head: "And I thought we were going to save money by using our own stones and timber."

Finally we arrived at the Abbey library. We soon stood before several large shelves of books on the life and works of Vincent van Gogh. I recognized many titles from works on my own office shelves. He offered, "Choose whatever you want, and I'll take you to a quiet study room." I chose the three volumes of van Gogh's letters. Nouwen

had written comments in the margins, underlined passages, and pencilled in circles and arrows to indicate passages he thought were most important. I was excited. A monk arrived and handed the abbot five large metal files of slides. We started for another part of the monastery where there would be a quiet, sunny room with chairs and a study table.

The abbot left me. I skipped the offered meals and stayed at my work, reading all the marginal notes and markings in the volumes of van Gogh's letters and viewing most of the slides. Henri noted which paintings were being described by Vincent for his younger brother, Theo. He circled the assigned numbers of the letters he considered most enlightening regarding Vincent's deepest thoughts and concerns. Of special interest to him was the close relationship between Vincent and Theo. Over and over again he wrote "T and V" if a letter illuminated some aspect of that deep friendship. Equally frequent was the notation "suffering" to mark poignant passages. Vincent's tenth letter to his artist friend Emile Bernard includes a story illustrating that a studio-trained "professional artist" might see little in a landscape that is recognized as beautiful by the untrained eye of a soldier. Henri wrote beside this passage, "like a Gospel story." Knowing Nouwen's profound and abiding appreciation for Vincent van Gogh inspired me. He would be a companion on my own search.

It was growing dark and the Abbey was at prayers. I left a note of thanks for the abbot and began my hike

back through the wheatfields toward Piffard and Geneseo. It was raining gently. I felt a sense of intimacy with Henri's unfinished quest and a closeness to the Abbey and Abbot John Eudes for his hospitality. I think Henri would have approved of my choices among Vincent's paintings and letters.

THREE

Vincent's Conversion to Painting

Henri Nouwen had written in the margin at a critical point in the first volume of Vincent's letters, "Conversion to Painting." How did such a conversion come about, and what was Vincent's life before that conversion to painting?

Vincent's father was a Dutch Reformed pastor, as was his father's father. Vincent's fondest hope was to follow in their footsteps. As he wrote to Theo early in their correspondence:

> As far as one can remember, in our family, which is a Christian family in every sense, there has always been, from generation to generation, one who preached the Gospel. (Letter 89)

Earlier he had confided to Theo his own professional hopes:

> Lately it seems to me that there are no professions in the world other than those of schoolteacher and

clergyman, with all that lies between the two —
such as missionary, especially a London missionary.

(Letter 70)

Limited by his lack of a university education, Vincent sought some form of church-related employment wherever he might find it. He traveled to England and sent a brief and revealing autobiography to a London clergyman, hoping that the gentleman might aid him in locating a position of some sort. Vincent described himself as:

> a clergyman's son who, as he has had to work for a living, has neither the time nor the money to study at King's College, and who besides is already a few years beyond the age at which one usually enters there and has as yet not even begun preparatory studies in Latin and Greek, would, notwithstanding this, be happy to find a position related to the Church, though the position of a graduated clergyman is beyond his reach. Though I have not been educated for the Church, perhaps my travels, my experiences in different countries, of mixing with various people, poor and rich, religious and irreligious, of different kinds of work — manual labor and office work — perhaps also my speaking a number of languages, may partly make up for the fact that I have not studied at college. But the reason which I would rather give for introducing myself to you is my innate love for the Church and everything connected with it. (enclosed in Letter 69)

Vincent's Conversion to Painting

In 1876 he found a temporary position aiding a Methodist clergyman in England. He was allowed to preach his first sermon in a tiny parish in the town of Richmond. He wrote Theo:

> When I was standing in the pulpit, I felt like somebody who, emerging from a dark cave underground, comes back to the friendly daylight. It is a delightful thought that in the future, wherever I go, I shall preach the Gospel. (Letter 79)

But Vincent's fondest hope was not to be. His father was the pastor of a succession of small Protestant parishes in the Roman Catholic South of the Netherlands. With little income and six children, there was no money for Vincent to get the university education required to pursue the theological degree necessary to become a Dutch Reformed clergyman.

As molting time — when they change their feathers — is for birds, so adversity or misfortune is the difficult time for us human beings.

Vincent tried alternate routes. He was tutored for a time in Greek and Latin and other courses preparatory to entering the university. He begged to be admitted to a school for evangelism in Belgium and went at his family's expense as a probationary evangelist to the poverty-stricken mining district of Belgium called the Borinage.

Even there he was thwarted. A board of evangelism rejected him at the end of the probationary period. His lack of formal education and his preference for dressing and living as simply as the miners themselves are likely among the reasons the hierarchy viewed him as unfit to become a "respectable" evangelist.

In agony over his failed life mission, Vincent hid himself in one of the mining villages, read every book he could get his hands on, and searched for some mission that would make his life worthwhile. He wrote a poignant letter to Theo:

> As molting time — when they change their feathers — is for birds, so adversity or misfortune is the difficult time for us human beings. One can stay in it — in that time of molting — one can also emerge renewed; but anyhow it must not be done in public and it is not at all amusing, therefore the only thing is to hide oneself. (Letter 133)

He also made clear his deep disappointment in the church as an institution with a rigid hierarchy, as he experienced it:

> I must tell you that with evangelists it is the same as with artists. There is an old academic school, often detestable, tyrannical, the accumulation of horrors, men who wear a cuirass, a steel armor, of prejudices and conventions; when these people are in charge of affairs, they dispose of positions, and by a system

of red tape they try to keep their protégés in their places and to exclude the other man.

Vincent's painful search for a new life mission is evident:

> A caged bird in spring knows quite well that he might serve some end; he is well aware that there is something for him to do, but he cannot do it. What is it? He does not quite remember. Then some vague ideas occur to him, and he says to himself, "The other birds build their nests and lay their eggs and bring up their little ones"; and he knocks his head against the bars of the cage. But the cage remains, and the bird is maddened by anguish.

Not long after, Vincent made a choice that unlocked his cage and changed the nature of his ministry to the world. He described the moment for Theo:

> Well, even in that deep misery I felt my energy revive, and I said to myself, in spite of everything I shall rise again; I will take up my pencil. From that moment everything has seemed transformed for me.
>
> (Letter 136)

It had come to Vincent that if he were not allowed to preach to the miners, he would draw these largely ignored and forgotten workers who deserve our attention. Putting their faces "before the eyes of the people" would be a healing act:

> The miners and the weavers still constitute a race apart from other laborers and artisans, and I feel a

great sympathy for them. I should be very happy if someday I could draw them, so that those unknown or little-known types would be brought before the eyes of the people. The man from the depth of the abyss, de profundis — that is the miner.

He had hoped to "preach the Gospel to the poor." Now he would show the poor and their way of life to those who had forgotten their obligations to these broken and vulnerable ones. This attention to the underside of things, to the ordinary and ignored, soon became Vincent's chief work in art. He identified with these forgotten people in his own difficulties. Vincent would show what was hidden in himself and so what was hidden in them:

> I should want my work to show what is in the heart of such an eccentric, of such a nobody.... It is true that I am often in the greatest misery, but there is a calm pure harmony and music inside me. I see drawings in the poorest huts, in the dirtiest corner. And my mind is drawn to these things by an irresistible force. (Letter 218)

So Vincent began. He found a way of salvation by showing the world the inner illumination of the simplest people, plants, fields, and paths he encountered, and the deep emotions those scenes stirred in his heart. Vincent's art became his mission in life and a spiritual way of healing and comfort for others.

Theologians may have ignored the rich spiritual resources to be found in Vincent's work, but over twenty

years ago Meyer Shapiro, a sensitive art historian, described van Gogh's artistic career as "a high religious moral drama":

> What is most important is that van Gogh converted all this aspiration and anguish into his art, which thus became the first example of a truly personal art, art as a deeply lived means of spiritual deliverance or transformation of the self.[13]

Vincent struggled to fulfill his dream of becoming a clergyman until he was twenty-seven. It would be only ten years from the moment he picked up his pencil and gave himself his first lesson from a beginner's drawing manual until his death at thirty-seven.

I arrived at the National Gallery of Art in Washington, D.C., one November morning in 1998, before dawn. A long line of figures huddled together outside the Gallery's back entrance in the semidarkness. It was raining, and a mist rose from the ground. Few in the crowd had thought to bring umbrellas, so we bent our heads as the rain dripped from our hair. We stood in that drizzle for hours waiting for the Gallery to open. There was some consolation in the vague forms of hundreds who arrived after us, creating a line that disappeared around the side of the building. We were hoping to be among the first four hundred people without reservations to receive same-day tickets, for "Van Gogh's Van Goghs," seventy paintings on loan from the Van Gogh Museum.[14] Attendance at the Van Gogh Museum in Amsterdam, which houses over two hundred of Vincent's paintings,

five hundred of his drawings, and seven hundred of his letters, had surpassed a million visitors a year, and so the museum was being expanded through a new wing designed by Kisho Kurokawa. While the expansion was in progress, the museum closed, allowing some of the paintings to travel to Washington. The chances of these paintings ever traveling again was small. Their enormous value makes insurance for travel almost impossible.

> *Vincent began sending his work to Theo; he felt the drawings and paintings belonged to them in common.*

Vincent's first sermon had been on the theme of pilgrimage, and I thought of these paintings as pilgrims, far from the refuge of their Dutch home. Vincent had begun his sermon with the words of Psalm 119 and continued with his own searching interpretation:

> I am a stranger on the earth, hide not Thy commandments from me. It is an old belief and it is a good belief that our life is a pilgrim's progress — that we are strangers on the earth, but that we are not alone for our Father is with us. We are pilgrims, our life is a long walk or journey from earth to Heaven.
> (following Letter 83)

Vincent's paintings were making a pilgrimage he never made, being greeted by appreciative crowds he never saw. Among Vincent's own dreams of pilgrimage was the hope

to paint in the tropics, as Gauguin did, or to paint in the liquid sunshine of Japan. Though Vincent did finally leave his homeland to pursue his painting, he was never very far from his birthplace in Zundert, Holland. He had been sent as a young art clerk to Paris and London. He had been a missionary in Belgium. He had painted the wheatfields and orchards of Provence, in the south of France. And he had spent the last seventy days of his life in the little village of Auvers on the Oise River northwest of Paris.

Though the exhibit at the National Gallery in Washington was titled "Van Gogh's Van Goghs," I thought of it as "The Paintings under Theo's Bed." It pained Vincent that Theo was burdened with the task of supporting him as he struggled to learn his art. Each month Theo sent a part of his limited earnings as an art clerk for Vincent's room, board, and painting materials. Theo had taken on Vincent's support voluntarily, but Vincent had hoped his drawings would allow him to be self-sufficient and to repay his brother. That did not happen. Vincent began sending his work to Theo; he felt the drawings and paintings belonged to them in common. Theo put the growing collection of works on his walls, in closets, even under his bed. At first Vincent had hoped that Theo would be able to sell some of the pictures, but they failed to attract buyers. He wrote Theo in 1888 from Provence:

> If you asked me what would please me, it's just this one thing: that you keep in the apartment for yourself whatever you like of my work, and sell none of it now. (Letter 563)

Out of both the pain of Vincent's realization that his paintings could not sell and Theo's sacrificial support of Vincent's painting in spite of that, this great collection remained in the van Gogh family.

That morning in the rain and mist I had time to think about Vincent's embracing his new mission with such passion, creating paintings despite what he called "the siege of failure" that he assumed would last his lifetime and require that he and artists like himself "live almost like monks and hermits, with work for our master passion, and surrendering our ease" (Letter 523). But I remembered from his letters that even during the darkest of these days Vincent did not allow himself to fall into self-pity and depression. Without having sold a single painting, when a new roll of canvas arrived from Theo, Vincent could joke with his brother:

> Provided that on the 10 meters of canvas I paint only masterpieces half a meter in size and sell them cash down and at exorbitant prices to distinguished connoisseurs of the Rue de la Paix, nothing will be easier than to make a fortune on this package.
>
> (Letter 521)

As I considered Vincent's painting in relation to his earlier ambition to be a clergyman, a strange sort of miracle hovered there in the morning mist where we'd gathered. Who of us would have stood in the rain before dawn to hear Vincent the Dutch Reformed Pastor preach a sermon? But we were here, and crowds like us would gather every dawn for months for the privilege

of standing before those seventy paintings. When they moved on to California, the gallery stayed open twenty-four hours to accommodate the unprecedented crowds. Vincent's creation of a body of art touched millions of people's lives as no sermon he could have preached.

In the line just ahead of me were a woman and her daughter. The daughter was apparently an art history major who had talked her mother into this excursion. They chatted as they stood in the rain. One exchange sticks in my mind. The mother said, "Isn't he the one who cut off his own ear?" The daughter answered, "He had problems, Mom." The mother stood quietly for a moment, and then answered gently, "Don't we all, honey, don't we all."

Perhaps Vincent's paintings, born of failure and suffering, do have a special power to speak to people with failures and sufferings of their own.

FOUR

The Birth of God
Vincent and the Cradle

Vincent van Gogh's love for children touched such a deep place in his being that the cradle became to him a symbol for revelation itself. Vincent related the child in its cradle to "the eternal poetry of the Christmas night with the baby in the stable" (Letter 213). The child, for Vincent, was "light in the darkness," God's way into our world in a vulnerable form that calls for caring and sacrifice on our part. Recognition of the child as God's birth among the poor was essential to Vincent's sense of the divine presence in a difficult world.

When Vincent's position as an evangelist to Belgian miners was terminated by his superiors, he "took up his pencil" and learned to draw those he was not permitted to serve as teacher and preacher. Pursuing his new life as artist would be cheaper if he lived at home, so he moved into his parents' parsonage at Etten. On Christmas Day of 1881, Vincent's father, Pastor Theodorus van Gogh, reproved his son for not attending church services and a "violent scene" followed. Pastor van Gogh told his son to leave the house (Letter 166). Vincent packed

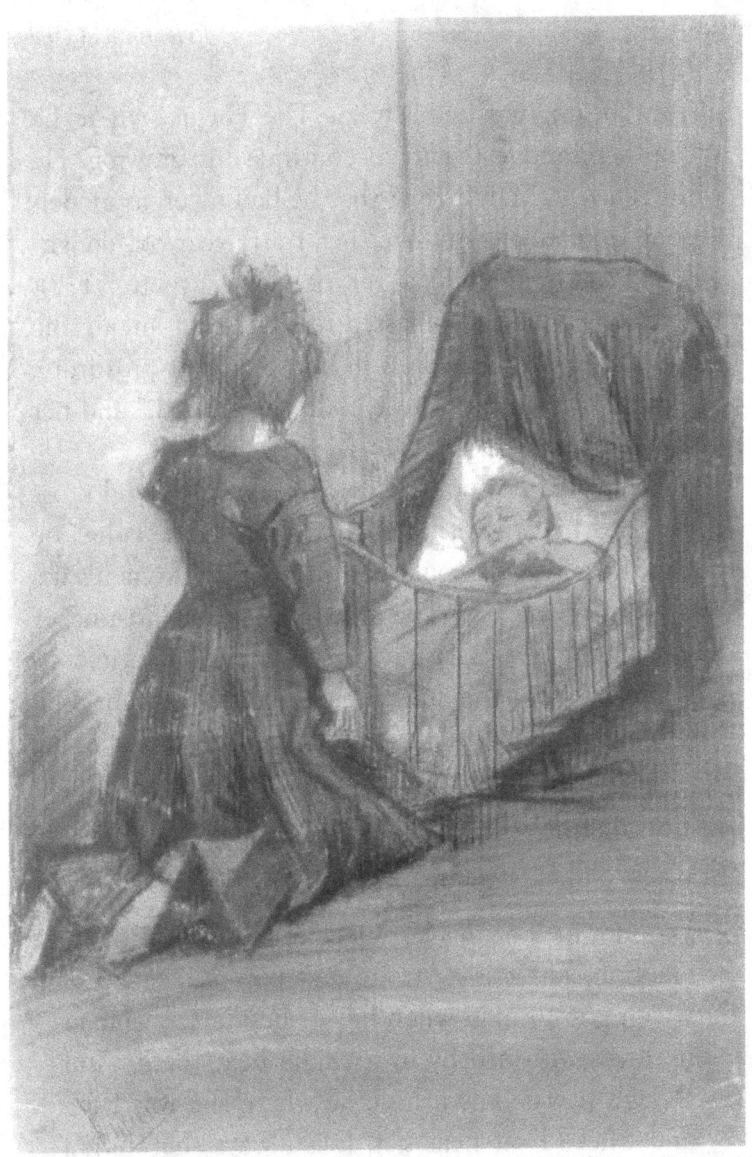

Child in Cradle with Kneeling Girl. The Hague, March 1883. F1024, JH336, black chalk and pencil, 18⅞ x 12⅝″. Vincent van Gogh Foundation, National Museum Vincent van Gogh, Amsterdam. See page 144 below for an explanation of the numbering system used to identify van Gogh's works.

his few belongings and left for The Hague, where he set up a primitive studio to continue his drawing. He wrote Theo in March 1882 that he had taken as models a poor woman of forty-five, her thirty-year-old daughter, and "a young child of ten or twelve" (Letter 178). Before long Vincent confessed to Theo that among the models he spoke of was an ill and pregnant prostitute, "deserted by the man whose child she carried," and her young daughter (Letter 192).

Vincent had not only taken this dangerously ill prostitute into his studio; he soon wrote to Theo that he believed the way he could best protect the woman's life was by marrying her. The woman, called Christine or Sien (her name was Clasina Maria Hoornik), was in danger of losing her child and perhaps her life. Vincent took her to a free clinic, she was hospitalized, and after a long stay she gave birth to a healthy child.[15] After the difficult birth, Vincent wrote of his deep emotions as he viewed the cradle in the poor ward of the hospital:

> I cannot look at this last piece of furniture without emotion, for it is a strong and powerful emotion which grips a man when he sits beside the woman he loves with a baby in a cradle near them. And though it was only a hospital where she was lying and where I sat near her, it is always the eternal poetry of the Christmas night with the baby in the stable — as the old Dutch painters saw it, and Millet and Breton — a light in the darkness, a star in the dark sky. (Letter 213)

Vincent had already placed "a small iron cradle with a green cover" in his studio and hung over it Rembrandt's etching of two women by a cradle, one reading the Bible by candlelight. The presence of the cradle, for Vincent, marked his studio as one truly rooted in life. He wrote Theo:

> — a new studio, a young home in full swing. No mystical or mysterious studio but one that is rooted in real life — a *studio with a cradle*, a baby's potty chair — where there is no stagnation, but where everything pushes and urges and stirs to activity.
>
> <div align="right">(Letter 212)</div>

It is that "small iron cradle" that Vincent sketched in black chalk and pencil in the autumn of 1883. It is in a corner of Vincent's studio in The Hague. Christine's daughter kneels at its foot, her left hand on the cradle, her face hidden from us as she views her tiny brother. The baby's face is drawn with a sensitivity and delicacy not often found in Vincent's portraits. The child sleeps peacefully, one hand holding the blanket to his chest. Vincent later wrote:

> But if one feels the need for something grand, something infinite, something that makes one feel aware of God, one need not go far to find it. I think I see something deeper, more infinite, more eternal than the ocean in the expression of the eyes of a little baby when it wakes in the morning, and coos or laughs because it sees the sun shine on its cradle. If

there is a "ray from on high," perhaps one can find it there. (Letter 242)

The cradle was a place of revelation, and he goes on to speak of the divine presence he felt:

> Without preaching a sermon, it may be true that there is no God here, but there must be one not far off, and at such a moment one feels his presence. Which is the same as saying, and I readily give this sincere profession of faith: I believe in God, and that it is his will that man does not live alone, but with a wife and a child, when everything is normal.
>
> (Letter 213)

But everything was not normal, and Vincent was soon to lose this strange family he had sought to protect, this child whose life he had saved. The story is complicated and incomplete, but it appears that Pastor van Gogh and his wife, and perhaps two wealthy van Gogh uncles concerned about the family name, all thought the proposed marriage of a van Gogh to a prostitute with children was out of the question. It was hinted that there might be a court order to have Vincent declared incompetent. Theo, Vincent's only means of support, was pressured by the family to discontinue financial aid. Vincent went into debt and was even beaten by one of the merchants he owed money.

Christine's mother and brother too, who likely had benefited by her earlier prostitution, soon realized that

Vincent and the Cradle

Vincent's painting cost money but brought no money in. They encouraged her to return to the streets.

Brokenhearted, Vincent agreed with Theo that he must leave The Hague. He took a train into the region called Drenthe, barren stretches of heath where peasants gathered peat. Without funds and without paints, Vincent made drawings of the desolate scenes around him. He tells us that hiking the countryside, "when I meet on the heath such a poor woman with a child on her arm or at her breast, my eyes get moist.... It cuts right through me" (Letter 324). Still shattered by the response of his family to Christine, Vincent quoted words from the gospel:

> I for my part understand Jesus' words when He said to the superficially civilized, the respectable people of His time, "The harlots will go into the Kingdom of God before you." (Letter 326)

In the same letter, he thought again of the little boy he had placed in that cradle in his studio:

> As I told you, the little boy was very fond of me, and when I was already on the train I still had him on my lap, and so I think we both parted with inexpressible sadness. (Letter 326)

Vincent took a room in a farmhouse-inn on the heath. When the loneliness of his room became oppressive after a day of hiking and sketching, he would descend the stairs and join the innkeeper and his family in the kitchen. In several letters he described this scene for

Theo, focusing on the family's child in a cradle beside the window:

> I think there is no better place for meditation than by a rustic hearth and an old cradle with a baby in it, with a window overlooking a delicate green grainfield and the waving of the alder bushes.
>
> (Letter 334)

He returned to this theme in letter after letter, marking its importance. The vulnerable child sleeping in its cradle and the young grain outside both promise new life. A window between cradle and green stems of grain connects human life and nature, cradle and fertile field, the Creator and a new creation, the outer world and our interior musings.

Vincent affirmed to the end of his life that his painting belonged below the tasks of workers and peasants who lived in families and cared for the greatest of artistic creations, their children.

Vincent had a sense of special intimacy and understanding of God's creative ways; he saw God's creative art arriving in the form of a baby born in a stable among the poor. If God as Creator is an artist, then not only is the child in the manger his special artistry, but that child also incarnates the Creator-artist. So wrote Vincent to his young artist-friend, Emile Bernard:

He lived serenely, *as a greater artist than all other artists*, despising marble and clay as well as color, working in living flesh. That is to say, this matchless artist, hardly to be conceived of by the obtuse instrument of our modern, nervous, stupefied brains, made neither statues nor pictures nor books; he loudly proclaimed that he made...*living men*, immortals. (Letter B8)

Vincent took seriously this image of Christ's art accomplished in "flesh and blood." Rather than joining the many artists who saw themselves as a kind of high priesthood above the common lot, Vincent repeated in his letters that loving, marrying, and having children took precedence over painting pictures. Vincent affirmed to the end of his life that his painting belonged below the tasks of workers and peasants who lived in families and cared for the greatest of artistic creations, their children. Vincent's final letter to his mother speaks of this:

Last year I read in some book or other that writing a book or painting a picture was like having a child. This I will not accept as applicable to me — I have always thought that the latter was the more natural and the best — so I say, only *if* it were so, only *if* it were the same. (Letter 641a)

Vincent carried the image of the newborn and its relation to the Christ child in the manger even further as he affirmed birth in nature as the very height of artistic creativity. He objected vehemently that his friend

Emile Bernard's painting *Adoration of the Magi* was missing the point of the sacredness of everyday life.[16] Vincent gave an example of what he considered a truly religious painting, a work by Millet that shows a newborn calf being carried from the fields back to the farmhouse for special care. The newborn calf on its pallet of hay is a sacred presence. It calls Christmas morning to mind. Vincent describes it as "powerful enough to make a Millet tremble" (Letter B21).

Within the context of the birth of the holy in the ordinary events of life, Vincent's drawing of a prostitute's child in the cradle opens the way to an incarnational spirituality available to any who have ever cared for a newborn, whether human, animal, or plant. God is born into the simplest settings and is in need of our loving care.

FIVE

The Mystery of His Father's Bible

There is no doubt that many van Gogh pictures have spoken powerfully to millions over the last century. His dark portraits of miners, weavers, and peasants at work in Belgium and Holland; bright vases of flowers and landscapes from Paris; sun-drenched wheatfields, blossoming trees, and sunflowers from Provence; stormy skies over wide fields from Auvers-sur-Oise — all call for our attention and participation. I regularly show slides of these paintings to students, scholars, and church and civic groups, and many viewers recognize a large number of those paintings as the work of van Gogh. But no one other than art historians and critics recognizes Vincent's painting of his father's Bible. Yet Vincent especially wanted that picture to speak a particular word of wisdom to us.

At the time Vincent did this painting, his life had already suffered several disappointments and losses. He had failed in his goal of becoming a pastor despite his strenuous efforts. He had been dismissed from his position as an evangelist to Belgian miners, despite his sacrificial

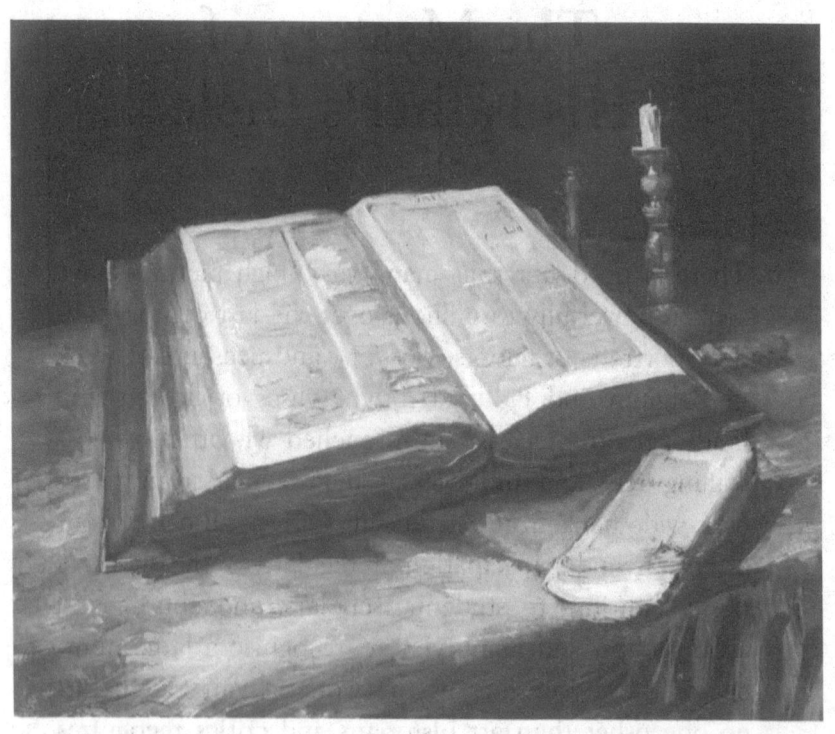

Still Life with Open Bible and Zola Novel. Neunen, Autumn 1885. F117, JH946, oil on canvas, 25⅝ x 30¼". Vincent van Gogh Foundation, National Museum Vincent van Gogh, Amsterdam.

service to those struggling workers. He had begun his work as artist in the mining villages of Belgium and continued at his parents' parsonage in Etten. He settled in The Hague, then lost that chance at family life, and wandered in Drenthe. Discouraged and penniless, he swallowed his pride and returned to his parents' parsonage, now in a village called Neunen. He stayed there from December 1883 to November 1885, his longest stay in one place during his life as an artist. He sketched peasants and weavers at work, jars and clogs and potatoes, and took on an art student or two.

During that time, on March 27, 1885, his father died of a stroke at age sixty-three. From the parsonage, Vincent wrote Theo:

> Indeed, those were days we shall not easily forget. And yet the total impression was not terrible, only solemn. Life is not long for anybody, and the problem is only to make something of it. (Letter 397)

Vincent memorialized his father's death by painting his father's open Bible on a table with a snuffed-out candle and a paperback novel. These few objects carried a heavy freight of meaning for van Gogh. They were the pieces of a puzzle he sought to assemble, the furnishings of his life through which he hoped to discover meaning. As he would do repeatedly during the remaining five years of his life, he expressed his spiritual quest in the simple objects around him and sought to find his own reason for being by offering his personal icons to

the world. The stuff of his own life manifested the spirit and its movement in ordinary things.

I spent many hours viewing that painting in the Van Gogh Museum in Amsterdam. His father's Bible dominates the painting. The snuffed-out candle is found in many Dutch *memento mori* paintings, remembering a death and reminding viewers of the stark reality of their own limited life span. Two bronze objects near the candlestick are metal latches hinged to the Bible's cover. Each page of the old Dutch Bible has biblical text on the top half of the page, and a popular commentary with Bible-helps on the lower.

Far more important for the painting are the word "ISAIE" painted at the top of the right-hand page, and the Roman numerals "LIII" near the right-hand margin of that page. Vincent has painted the Bible opened to one of the most famous passages in the Hebrew prophets, one of the "Suffering Servant Songs" in the Prophet Isaiah, chapter 53.[17]

Although the Bible dominates by size, the small yellow paperback novel nudging the lower edge of the Bible dominates by color. It is "a touch of citron yellow" in an otherwise dark and somber painting. On the worn, dog-eared cover we read "Emile Zola," and "La Joie de vivre." Below those words one can just make out the word "Paris" near the bottom of the cover. Vincent has placed next to his father's Bible a copy of Zola's *The Joy of Living*, published that year, 1885.[18]

The contrast between Bible and modern novel witnesses to the conflict between father and son when

Vincent returned to his parents' home in 1883. Vincent's letters to Theo describing the difficulties for both father and son living under the same roof but holding such different views of life are poignant. He described his feelings to Theo:

> Father and Mother... feel the same dread of taking me into the house as they would about taking a big rough dog. He would run into the room with wet paws — and he is so rough.... In short, he is a foul beast.... And then — the dog might bite — he might become rabid, and the constable would have to come to shoot him. (Letter 346)

Vincent goes on to confess, "The dog is only sorry that he did not stay away." He embraced his status as an artist, an outcast:

> I tell you, I consciously choose *the dog's path through life;* I will remain a *dog,* I shall be *poor,* I shall be a *painter.* (Letter 347)

The significance of Vincent's nudging a Zola novel against his father's Bible is even clearer when considering the arguments he had with his father before he was ejected from the parsonage in 1881. Vincent had written Theo:

> When Father sees me with a French book by Michelet or Victor Hugo, he thinks of thieves and murderers, or of "immorality"; but it is too ridiculous, and of course I don't let myself be disturbed by

such opinions. So often I have said to Father, then just read it, even a few pages of such a book, and you will be impressed yourself; but Father obstinately refuses. (Letter 159)

The painting displays the essential conflict between his father's closed mind that claimed all truth for the Bible read in a traditional way and Vincent's mind that accepted the possibility that truth could be found in more adventurous reading of the Bible and among the works of the writers of his own day.[19]

Isn't it true that saying a thing well is as interesting and as difficult as painting it?

Even though battles with his father deeply grieved Vincent, he explained to Theo, "of course I love Father," but

> Father cannot understand or sympathize with me, and I cannot be reconciled to Father's system — it oppresses me, it would choke me. I too read the Bible occasionally just as I read Michelet or Balzac or Eliot; but I see quite different things in the Bible than Father does, and I cannot find at all what Father draws from it in his academic way. (Letter 164)

Vincent had actually suggested to Theo, while their father was still alive, that he could have been a help to the pastor:

> So I do not consider Father an enemy, but a friend who would be even more my friend if he were less afraid that I might "infect" him with French "errors" (?) I think if Father understood my real intentions, I could often be of some use to him, even with his sermons, because I sometimes see a text in quite a different light. But Father thinks my opinion entirely wrong, considers it contraband, and systematically rejects it. (Letter 161)

Vincent's painting, even as it memorializes his father's death, does not give an inch to his repressive ideas:

> We are full-grown men now and are standing like soldiers in the rank and file of our generation. We do not belong to the same one as Father and Mother and Uncle Stricker; we must be more faithful to the modern than to the old one — to look back toward the old one is fatal. (Letter 160)

But an even deeper level of meaning, beyond the contrast between Bible and novel, is discernable in Vincent's painting, a further level that has been missed even by many careful critics. The tragic part of his father's misunderstanding is that the clergyman could see only the contrast. Vincent's painting is telling us that a Zola novel speaks the same truths as the prophets of old. The painting is a revelation of Vincent's understanding of the prophetic mission of the artist, whether writer or painter. It is a visual image of his understanding of his own mission.

So Vincent opened the Bible not to restrictive commandments or the warnings of evil his father stressed. Vincent also avoided the Parable of the Prodigal Son, which had once been a favorite of his. He no longer saw himself as a prodigal in relation to his father. The Bible was opened to his own experiment in biblical living, the mission of the Suffering Servant he had wholeheartedly taken on among the miners in the Borinage.[20] Chapter 53 of Isaiah describes God's disfigured and misunderstood servant:

> He was despised and rejected of men;
> A man of sorrows, and acquainted with grief....
> Surely he has borne our griefs and carried our
> sorrows;
> Yet we esteemed him stricken,
> smitten by God, and afflicted. (Isaiah 53:3, 4)

Vincent's painting was his opportunity to demonstrate the truth his father had refused. He painted the Bible opened to a text that shows someone whose willingness to suffer has the power to heal others. And Zola's novel was his choice because it communicated the Servant Song of Isaiah in modern dress. *La Joie de vivre* depicts a bourgeois family that is as miserable and complaining as one can imagine. Mr. Chanteau's gout makes every movement painful, his wife is self-centered and greedy, and their son, Lazare, is a weakling who runs from every challenge. Pauline Quenu, an orphan, is put in their charge, and though they steal her inheritance, betray her, and misuse her love, she remains a ray of light

in the household and an angel of charity in their poor fishing village. Ultimately, she saves the life of the newborn child of Lazare — the man she had once hoped to marry — and his new wife, a shallow and bad-tempered temptress. Their apathy leaves the child to her care. It is a drama of light shining in darkness. Zola describes Pauline as:

> the incarnation of renunciation, of love for others and kindly charity for erring humanity.... She had stripped herself of everything, but happiness rang out in her clear laugh.

The Suffering Servant of Isaiah and Pauline Quenu are both incarnations of renunciation, sacrifice, and charity. It was fitting that Zola expressed the Servant mission for a new age in a new body, a joyful young girl, and expressed hope in the form of a child she vowed to raise in the midst of darkness and death.

Vincent believed the art of words and books was to be appreciated equally with the art of images and painting:

> There are so many people, especially among our comrades, who imagine that words are nothing — on the contrary, isn't it true that saying a thing well is as interesting and as difficult as painting it? There is the art of line and colors, but the art of words is there nonetheless, and will remain. (Letter B4)

In 1881, while at the parsonage in Etten, he recommended that Theo read the works of "Michelet and

Beecher Stowe, Carlyle and George Eliot and so many others," and continued:

> It is true the Bible is eternal and everlasting, but Michelet gives such practical and clear hints, so directly applicable to this hurried and feverish modern life in which you and I find ourselves, that he helps us to progress rapidly; we cannot do without him. The Bible consists of different parts and there is growth from one to the next; for instance, there is a difference between Moses and Noah on the one hand, and Jesus and Paul on the other. Now take Michelet and Beecher Stowe: they don't tell you the Gospel is no longer of any value, but they show how it may be applied in our time, in this our life, by you and me, for instance. (Letter 161)

Six years later, advising his youngest sister, Wilhelmina, Vincent continued his thoughts on the relation between the Bible and contemporary literature:

> Is the Bible enough for us?
> In these days, I believe, Jesus himself would say to those who sit down in a state of melancholy, It is not here, get up and go forth. Why do you seek the living among the dead?
> If the spoken or written word is to remain the light of the world, then it is our duty to acknowledge that we are living in a period when it should be spoken and written in *such* a way that — in order to find something equally great, equally good, and

equally original, and equally powerful to revolutionize the whole society — we may compare it with a clear conscience to the old revolt of the Kristians.

In that same letter to his sister, he continues with a more personal application:

> I myself am always glad that I have read the Bible more thoroughly than many people nowadays, because it eases my mind somewhat to know that there were once such lofty ideas. But because of that very fact that I think the old things so beautiful, I must think the new things all the more beautiful. All the more, seeing that we can act in our own time, and the past as well as the future concern us only indirectly. (Letter W1)

Vincent's letters make clear that his own mission as modern artist was to create "new things" with the beauty and revolutionary power to transform lives that one found in the "old things" of the Bible. Vincent's painting proclaimed both his mission in the tradition of Isaiah's Suffering Servant and the need for acting in his own time through something "equally original."

He distinguished himself from his fellow artists Gauguin and Bernard, who conjured up biblical images in their paintings to depict the sacred. When Bernard sent photographs of his biblical paintings *Adoration of the Magi* and *Christ in the Garden of Olives* to Vincent at the asylum in Saint-Rémy, Vincent wrote to Theo:

The thing is that this month I have been working in the olive groves, because their Christs in the Garden, with nothing really observed, have gotten on my nerves. Of course with me there is no question of doing anything from the Bible — and I have written to Bernard and Gauguin too that I consider that our job is thinking, not dreaming. (Letter 615)

To Vincent, the sacred is available in the scenes of our everyday life, and we should experience it there. The artist, writer or painter, is responsible for revealing the healing truth incarnate in contemporary life. Vincent's painting of a cradle, of the cafés where he met friends, of his bedroom, his chair, the postman's wife, a wheatfield, show the sacred that is to be met in the ordinary. It is there that suffering service and the joy of life meet.

SIX

Empty Shoes
A Ghost Story

Two leather workshoes stand beside each other, the laces stiff and twisted. The shoes' ankle-high leather tops are worn and bent this way and that, revealing the dark interiors. The body and toes of the shoes are ridged from long wear and muddy from recent use. A misty golden-white background sets off the brown leather like an encircling halo. Only their shadow falling to the left of the shoes anchors them.

If most people's lack of acquaintance with Vincent's painting of his father's Bible is a puzzle, the wide popularity of this painting of old shoes is an equal and opposite mystery. Among scores of luminous paintings of sunflowers and irises, wheatfields and blossoming orchards, people of all ages are drawn to this painting of old shoes. Jacques Derrida, the French philosopher, devoted a lecture, "Restitutions," to this one painting. Perhaps in that lecture he posed the mystery best:

> Who said... "there are no ghosts in Van Gogh's pictures"? Well, we've got a ghost story on our hands here all right.

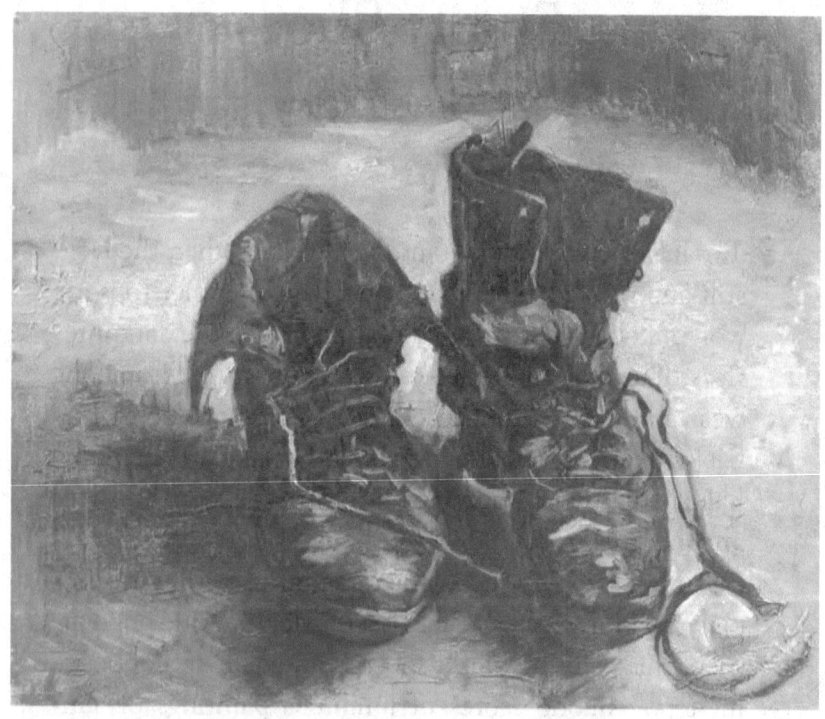

Pair of Old Shoes. Paris, July–September 1886. F255, JH1124, oil on canvas, 15 x 18⅛″. Vincent van Gogh Foundation, National Museum Vincent van Gogh, Amsterdam.

A Ghost Story

Vincent recognized that something important happened in the old shoes painting, for he went on to experiment several times with the theme. In Paris in 1886 and 1887 he did several paintings of old shoes and boots, and in Arles he painted a pair of shoes on the red tile floor of his Yellow House. François Gauzi (1861–1933), who was a fellow student of Vincent's at Cormon's studio, left us his remembrance of Vincent in Paris painting a pair of old work shoes. Gauzi recollected:

> Just then he was finishing a still-life which he showed to me. He had purchased at the flea market a pair of old, worn-out shoes, shoes of a street pedlar which nonetheless were clean and freshly polished. They were sturdy footwear lacking in fantasy. He put on these shoes one rainy afternoon and took a walk along the fortifications. Covered with mud, they appeared more interesting. A study is not necessarily a painting; army boots or roses might have served just as well. Vincent copies his pair of shoes faithfully. This idea, which was hardly revolutionary, appeared bizarre to some of us, his studio comrades, who could not imagine a plate of apples hanging in a dining room as a companion piece to a pair of hobnailed boots.[21]

When the German philosopher Martin Heidegger saw the painting in an exhibition in Amsterdam in 1930 and was deeply moved, he used it as a demonstration of the meaning of a work of art in his essay "The Origin of the

Work of Art," delivered as a lecture in 1935 at Freiberg. Heidegger wrote:

> From the dark opening of the worn insides of the shoes the toilsome tread of the worker stares forth. In the stiffly rugged heaviness of the shoes there is the accumulated tenacity of her slow trudge through the far-spreading and ever-uniform furrows of the field swept by a raw wind. On the leather lie the dampness and richness of the soil. Under the soles stretches the loneliness of the field-path as evening falls. In the shoes vibrates the silent call of the earth.[22]

His essay goes on to say that the painting forces us to look at shoes devoid of their utility. Because we cannot put on these shoes in a painting, we are confronted by them in a new way. The work of art shows us a way of seeing apart from self-centered utility. But the art critic Meyer Shapiro attacked Heidegger's essay, concerned that Heidegger was searching for support for some Aryan "peasant-earth-and-blood" myth. As Shapiro notes, a peasant working in the wet fields would have worn wooden sabots; high leather shoes would have belonged to a city laborer. Derrida then joined the argument. From ordinary viewers to famous philosophers, that simple painting of old shoes has awed, fascinated, and mystified viewers for over a century.

I spent many hours in Amsterdam's Van Gogh Museum with this painting, and many more hours awake at night pondering the painting's haunting power to impress. There is an interesting parallel in Asian art,

A Ghost Story

particularly in Zen ink painting. The epitome of Zen art, a favorite that haunts the Zen imagination, is a painting of six persimmons in blacks and grays on an undefined background, the work of Mu-ch'i. It is among the greatest treasures of the Daitokuji Zen Temple. Chang Chung-yuan, a Chinese specialist in Zen philosophy and art, wrote:

> This picture of six persimmons is one of the best works ever produced by Chinese artists. Before Mu-ch'i picked up his brush, his mind was in the state of no-thought. Thus, we have in this painting a manifestation of the primary indeterminacy of the uncarved block. What his mind reflected at that moment his brush would put down.[23]

Yasuichi Awakawa, a Japanese philosopher and art critic, in his work entitled *Zen Painting* has this to say:

> The work relies for its best effect on the subtle use of ink tones and on the exquisite placing of the persimmons in relation to the surrounding space. The work is simple, yet absolutely nothing is left to chance; once again, one senses that only the artist with a thorough experience of Zen could have achieved such sureness of effect with such apparently simple means.[24]

Vincent loved, collected, and studied Oriental art. For one self-portrait he shaved his head and put on a "Buddhist" robe, aiming at "the character of a simple monk

worshiping the Eternal Buddha" (Letter 544a to Gauguin). Could it be that his use of space and his choice of the commonest of subjects in the old shoe painting reflects his participation in something akin to the Zen experience found in the persimmon painting? Perhaps it is this meditative "state of no-thought" that attracts the viewer.

Has Vincent, in these empty shoes, painted absence?

I have conversed with many who have selected the old shoe painting as a favorite. They are somewhat vague about its appeal. One viewer noted:

> There's no clue where the shoes are. It's a mystery. But I have the feeling someone just took them off, and is close by. It's the puzzle of who stepped out of those shoes and where he's been. I have the sense that those empty shoes want to tell me about someone who isn't there.

Does Vincent's work draw us in through the mystery of the unknown wearer of the shoes, whose presence we feel but experience as an absence? Monet's series of paintings viewing the changing light on a haystack or cathedral or lily pond at various times of the day might be described as painting the passage of time. Has Vincent, in these empty shoes, painted absence? Does that sense of a presence that hovers nearby like a ghost bring us into the meditative realm of solitude, deepening our musings

on the meaning of life? Perhaps the presence of absence in the old shoes is a clue to its unusual power.

Numerous other connections suggest themselves. Vincent was impressed by Thomas Carlyle's book *Sartor Resartus*, which develops a "philosophy of old clothes." Carlyle calls our clothing "the shells and husks of the body...the pure emblem and effigies of man."[25] Vincent's choice of the lowest portion of that human husk, the shoe, might have come from another of his favorite authors, Saint Paul, who uses the foot as an illustration of the honor owed to the lowest in society:

> For the body does not consist of one member but of many. If the foot should say, "Because I am not a hand, I do not belong to the body," that does not make it any less a part of the body.... But God has so adjusted the body, giving the greater honor to the inferior part, that there may be no discord in the body, but that members may have the same care for one another. (1 Corinthians 12:14–25).

If these old shoes, as Gauzi remembered, were purchased at a flea market, there is a further dimension. How do a laborer's worn shoes come up for sale? They were no doubt the poor man's only shoes, and it is likely his death that makes them available. Is Vincent thinking of himself standing in the shoes of the poor? That is the very stance he often emphasized as his place in society and in art. He stands in for the ghost of a laborer who could not outlive his shoes, and invites us to try on those very shoes, to experience the life of the laborer.

Perhaps there is also something of the liberation from toil brought by death, a concept found often enough in the death scenes in one of Vincent's favorite authors, Charles Dickens.

Vincent might well have thought of *A Christmas Carol*, which he tells us he read every Christmas season. Scrooge is taken to his deathbed, where he watches the rag-pickers gathering his belongings for sale, and to his own headstone in a misty cemetery. Confronted by his own absence, Scrooge undergoes a radical transformation. The liberated Scrooge now becomes like a child again, emptied of self-centeredness.[26] Perhaps Vincent thought of the poignant scene when Scrooge sees Tiny Tim's empty stool beside his small crutches in a corner of the Cratchit household. When Dickens himself died, Vincent tells us how moved he was by a memorial drawing of Dickens's empty chair. This is a hint of Vincent's intention when he painted Gauguin's empty chair, as Gauguin threatened to leave Arles, and his own empty chair as he contemplated the end of his dream of a colony of artists in the Yellow House. In one of van Gogh's final paintings, of a wheatfield with crows under a stormy sky, empty paths extend into a field, the central path disappearing in the ripe wheat.

Our sense of awe and meditative solitude in the presence of absence may well be at the heart of Vincent's painting of old shoes and several paintings like it. Absence invites our own imaginative participation in each scene, our own bringing to life the presence that would

make meaningful the emptiness while retaining its offer of liberation from excess and self-indulgence.

Vincent read and was impressed by Walt Whitman. Perhaps Vincent shared a sense of the need to leave much unsaid in order to involve the viewer. As Whitman wrote of his own work:

> I round and finish little, if anything.... The reader will always have his or her part to do, just as much as I have mine. I seek less to state or display any theme or thought, and more to bring you, reader, into the atmosphere of the theme or thought — there to pursue your own flight.[27]

It was Whitman who observed that behind every object, "a mystic cipher waits unfolded." Perhaps Vincent's old shoes call us to participate in just such a "mystic cipher" provided by the humble emptiness of a pair of laborer's shoes.

Antoine de Saint-Exupéry has been quoted as saying that "in anything at all, perfection is finally attained not when there is no longer anything to add, but when there is no longer anything to take away." Vincent may have come close to discovering such perfection when he took away everything but those two worn shoes and allowed them to invite our imaginative musings on absence, death, solitude, and the ghost of a laborer.

SEVEN

Blossoming Trees and Butterflies

In 1880, when he first took up his pencil to learn to draw, Vincent wrote Theo:

> Do our inner thoughts ever show outwardly? There may be a great fire in our soul, yet no one ever comes to warm himself at it, and the passers-by see only a wisp of smoke coming from the chimney, and go along their way. Look here, now, what must be done? Must one tend that inner fire, have salt in oneself, wait patiently yet with how much impatience for the hour when somebody will come and sit down near it — maybe to stay? Let him who believes in God wait for the hour that will come sooner or later. (Letter 133)

By 1883, one of the most difficult and depressing times in his life, he had fashioned a symbol for what he hoped might lie in his future. Hearing from Theo about an artist named Serret, who had produced a moving work of art in spite of hardship, Vincent replied:

Pear Tree in Bloom with Butterfly. Arles, April 1888. Sketch (JH1395) in Letter 477, showing Theo the subject of the oil painting he had just completed (F405, JH1394). Vincent van Gogh Foundation, National Museum Vincent van Gogh, Amsterdam.

When a rough man bears blossoms like a flowering plant, yes, it is beautiful to see; but before that time he has had to stand a great deal of winter cold, more than those who later sympathize with him know.

The artist's life, and what an artist is, it is all very curious — how deep it is — how infinitely deep.

(Letter 343)

If Drenthe and Neunen and even Paris were a part of his long, cold winter, his arrival in 1888 in Provence, the orchard-land of France, was his blossoming.

In February 1886 Vincent decided to move in with Theo in Paris. He experimented there with the bright colors of the Impressionists he had met. Paintings of flowers in vases, bridges, parks, and cafés brightened his canvases. He and Theo began collecting colorful Japanese prints, and Vincent copied some of them in oils to try to see the way Japanese artists saw. His departure in February 1888 to discover a country "as beautiful as Japan" in the south of France was sudden and his reasons for leaving complex. He would later recall: "When I left Paris, I was seriously ill, sick at heart and in body, and nearly an alcoholic" (Letter 544a). He was also restless and sensed that his mission could not be accomplished in Paris. Its cold winters and busy streets made painting outdoors difficult, and its quarreling artists made quiet meditation in nature impossible. In 1883 he had already written to Theo:

I do not intend to spare myself, nor to avoid emotions or difficulties — I don't care much whether I

live a longer or a shorter time.... "In a few years I must finish a certain work." (Letter 309)

But what was this "certain work" that he was to finish? In the somber world of Holland it had been to show the world the life of the forgotten laborers, miners, weavers, peasants. In Paris he had been called to learn the colors of the Impressionists. But still there was something more. He detected clues to this something more in the Japanese prints he and Theo collected through the Art Nouveau shop of Samuel Bing on Montmartre.[28] He marveled at the luminous unfolding of the seasons those prints revealed to Oriental artists who lived "in nature as though they themselves were flowers" (Letter 542). And so Vincent was both driven south by the difficulties of Paris and pulled south by the Japanese sun and the open countryside. The journey cost him a great deal. He was alone, a foreigner in a strange country, without family, without Theo at his side, without those few artists who had befriended him in Paris. What would he discover in the solitude of the fields of Provence?

Vincent had less than three years to live when he arrived on February 20, 1888, in the old Roman city of Arles on the Rhone River not far from the Mediterranean.[29] He rented a room near the railroad station where he had arrived. To his surprise, the land of sunshine was frozen. He wrote Theo that "there's about two feet of snow everywhere, and more is falling." But he sensed already what awaited him in Provence; he brought a blossoming almond sprig to his room and reported to

Theo that he had already done two little studies of it (Letter 466). Then the spring came. Within a few weeks he described for Theo the great orchards in full blossom. He wrote, "I feel as though I were in Japan" (Letter 469).

Vincent found more and more that he was not alone, but shared in the life of nature around him. He found companionship in the blossoming trees, the sprouting wheat, the sunflowers, and gained hope and inspiration in their presence. The companionship of nature was at once reality and symbol, what we might call a natural symbol or perhaps a radical sacrament of the union of nature and human life. As he would write Theo from the asylum during the autumn of 1889, the final autumn of his life:

> Well, do you know what I hope for, once I let myself begin to hope? It is that a family will be for you what nature, the clods of earth, the grass, the yellow wheat, the peasant are for me, that is to say, that you will find in your love for people something not only to work for, but to comfort and restore you when there is need for it. (Letter 604)

And so in the spring of 1888, Vincent's own blossoming was realized in the shared presence of the orchards of Provence. Surrounded by great clouds of petals, Vincent was in ecstasy and immersed himself in this luminous world. "I have just finished a group of apricot trees in bloom in a little orchard of fresh green," he writes (Letter 471). The following letter reports, "I have been

working... in the open air in an orchard, like a plowland, a reed fence, two pink peach trees against a sky of glorious blue and white" (Letter 472). And the next letter begins:

> I'm up to my ears in work, for the trees are in blossom and I want to paint a Provençal orchard of astounding gaiety. It is very difficult to think collectedly. (Letter 473)

He mentions a canvas of "blooming apple trees" he hopes Theo will put in his own room, and "another orchard, as good as the pink peach trees, apricot trees of a very pale pink. At the moment I am working on some plum trees, yellowish-white with thousands of black branches" (Letters 473, 474).

Vincent's excited letters from Provence bring back memories of viewing those paintings. I remember vividly the occasion some ten years ago when I first took my son Christopher, then about age five, to the Van Gogh Museum in Amsterdam. As we went from gallery to gallery, Christopher pointed to each painting and said, "Dad, I could do one just like that for you." When we arrived at the wall of paintings of blossoming peach, pear, apricot, and plum trees, he simply stared at them, and as we walked on he said, "Dad, I couldn't do paintings like that." Perhaps in the presence of Vincent's paintings of blossoming trees you have had a similar sense of amazement. In one painting the blossoms seem to take flight, a cloud from earth meeting the clouds in the sky. In another, Vincent takes you directly into the

orchard, and the dark boughs create the nave of a natural cathedral, while the light through the blossoms rivals any stained-glass window.

Vincent's painting of one awkward pear tree suggests the power of transformation hidden in the most ordinary things around us.

I had never appreciated one particular painting of blossoms until an experience I had this spring. I had gone to a local high school to see an early season tennis match. Before the match was to start, I wandered the school grounds and was attracted to a row of small pear saplings that had recently been planted. I smiled as I stood before one of those trees, barely a branch sticking out of the ground, yet giving its all to create puffs of white blossoms. The tree itself was misshapen, its slim branches rather chaotic. Then I noticed a bronze plaque at the foot of the tree. It had been planted in honor of a student who had been killed in an accident. The birth and death dates indicated that the student was fifteen, my own son's age, a time of awkward experimentation and untold energy. At that moment the memory of Vincent's painting of a similar pear sapling, a tangle of branches leaning to one side, became filled with meaning for me. In an instant it became one of my favorite paintings. It must have been a deliberate choice of subject for Vincent, a tree lacking in grace and beauty, yet

joining enthusiastically in the great blossoming of springtime. Perhaps Vincent was thinking of his own brief and awkward preparation as a painter flowering in spite of obstacles. Perhaps he was celebrating the odd branch that, like him, had seemed frozen and homely, yet had a hidden fire within it to allow it to blossom with such spirit and hopefulness.

I hunted in Vincent's letters for his description of the tree. He had intended it to be the center of a triptych of blossom paintings:

> I have also just now a little pear tree, vertical, between two horizontal canvases.... The ground violet, in the background a wall with straight poplars and a very blue sky. The little pear tree has a violet trunk and white flowers, with a big yellow butterfly on one of the clusters. (Letter 477)

I had never noticed the butterfly. It was another facet of nature that had become a symbol of new life for the artist (Letter B8).

Vincent's painting of one awkward pear tree suggests the power of transformation hidden in the most ordinary things around us. In pursuit of the art of life, even a rough man might make it through the winter to blossom, and even a caterpillar might one day emerge as a painter-butterfly.

The lifetimes of my favorite artist and of my favorite poet, Emily Dickinson, overlapped. I had once dreamed of them meeting in Emily's beloved garden in Amherst, Massachusetts. I wish Vincent had known the poems

on nature that were accumulating in a drawer in Emily
Dickinson's bedroom. In one poem she wrote:

> My cocoon tightens — Colors tease —
> I'm feeling for the Air —
> A dim capacity for Wings
> Demeans the Dress I wear —
>
> A power of Butterfly must be —
> The Aptitude to fly
> Meadows of Majesty implies
> And Easy sweeps of Sky —
>
> So I must baffle at the Hint
> And cipher at the Sign
> And make much blunder, if at last
> I take the clue divine — [30]

How much Vincent would have loved that poem, struggling to tend his inner fire and finding ecstatic days in the orchards of Provence. And Emily Dickinson would have understood his painting of that awkward pear tree and its butterfly.

EIGHT

Vincent's Bedroom
A Painting of Nothing at All

Vincent had exhausted himself by the middle of October 1888. His frenzied campaign to paint the orchards was followed by wheatfields, portraits, bridges, fishing boats, harvest scenes, flowers, cafés, and gardens. By the time his work in Arles came to a close — a period of 444 days — he had completed two hundred paintings and over a hundred drawings and watercolors. From the middle of August to the middle of October he completed fifteen two-feet-by-three-feet canvases, including several sunflowers, some landscapes, portraits of an old peasant, the artist Eugene Boch, the Zouave Milliet, a self-portrait, indoor and outdoor café scenes, his Yellow House, and the gardens nearby.[31] Such a collection of works in such a brief time was phenomenal.

On Sunday, October 14, Vincent wrote an unusually brief letter to Theo:

> I have been and still am nearly half dead from the past week's work.... I have just slept sixteen hours at a stretch. (Letter 553)

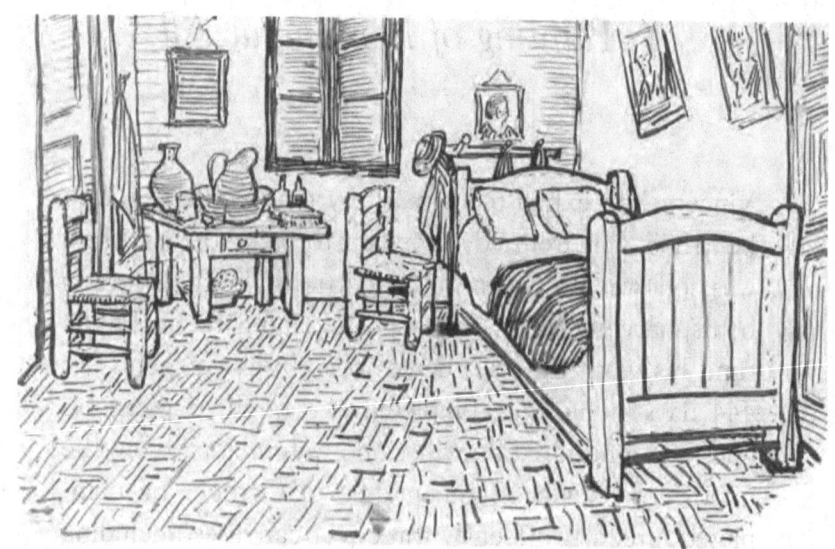

Vincent's Bedroom. Arles, October 16, 1888. Sketch (JH 1609) in Letter 554 showing Theo the subject of the painting he was working on (F482, JH1608). Vincent van Gogh Foundation, National Museum Vincent van Gogh, Amsterdam.

Tuesday, October 16, he reported that his "eyes are still tired," but he was already at work on a new painting:

> This time it is simply my bedroom, only here color is to do everything, and giving by its simplification a grander style to things, is to be suggestive here of rest or of sleep in general. In a word, looking at the picture ought to rest the brain, or rather the imagination. (Letter 554)

Giving thanks to his simple room for the rest it had given him, he painted the space as inviting the observer with its simple wooden bed, washstand, chairs, and muted light coming through partially closed shutters. His picture was to offer rest to all who viewed it.

Describing his bedroom painting to Theo, Vincent wrote that "there is nothing in this room with its closed shutters," and in the following letter he added that it had "no stippling, no hatching, nothing, only flat colors in harmony" (Letters 554, 555). Writing to Paul Gauguin, who was soon to join him in Arles, Vincent said, "Well, I enormously enjoyed doing this interior of nothing at all" (Letter B22; enclosure to Gauguin).

Vincent's description of the bedroom painting as an "interior of nothing at all" is reminiscent of another poem by Emily Dickinson. In 1883, just three years before her death and seven before that of van Gogh, she wrote:

> By homely gifts and hindered words
> The human heart is told

> Of nothing —
> "Nothing" is the force
> That renovates the World — ³²

Both poet and painter seem to have discovered the deep significance of the "homely" things of life, the moments and spaces so close to our lives that they become invisible to us. We sometimes describe such things as "nothing out of the ordinary." Perhaps the poet's words mean that the simplest and most profound meanings of life are already invisibly present in the human heart, and cannot be added from some external source.

It was certainly popular for painters to produce works showing us their studios, often crowded with curiosities collected on their travels, examples of their work, and, often enough, with the painter at his easel, his friends, and a model nearby. But the simplest laborer's bedroom hardly seemed the subject for a painting. A laborer's blue jacket and hat hang on pegs, but their owner is absent. The paintings on the bedroom wall are a landscape and two portraits Vincent painted of friends, Eugene Boch, whom he called "the Poet," and a Zouave soldier, Milliet. For all that, the room is vacant. Those things so common that they are taken for granted are the stuff of this painting. It makes luminous the forgotten corners of life and calls viewers to the sacrament of simplicity.

Most know the Dickinson poem "I'm Nobody! Who Are You?" Vincent, striving early in his career as an artist to find "pictures in the dirtiest corner," affirmed that he wanted his "work to show what is in the heart

of such an eccentric, such a nobody" (Letter 218). Perhaps "nobodies" are especially sensitive to those things we might describe as "nothing." A humility that moved in realms far deeper than ego provided both the poet and the painter with a profound vision of the meaningfulness of the ordinary.

But Vincent's bedroom had even more significance for him. Five months earlier, on May 1, 1888, Theo's thirty-first birthday, Vincent sent a hasty sketch of a building in the large square at the northern gate of Arles. It had two wings, and Vincent wrote Theo that he had rented the right wing, his Yellow House, for fifteen francs a month. He explained:

> Now my idea would be to furnish one room, the one on the first floor, so as to be able to sleep there. This will remain the studio and the storehouse for the whole campaign, as long as it lasts in the South.
>
> (Letter 480)

Vincent felt that he was being overcharged by the Hotel-Restaurant Carrel, where he stayed. In fact, he went to the local magistrate over a disputed bill. The judgment went in Vincent's favor and "the innkeeper was reprimanded" (Letter 487). But Vincent wished to be free of such "vexations," and his renting what he came to call his "little yellow house" was a happy liberation.

The Yellow House, which had four rooms, had been uninhabited for some time, was in poor condition, and had no gas for light or cooking. The lavatory was next door. No wonder the rent was very low. Vincent was

elated having a "home" to call his own despite its simplicity and inconveniences. He described it to Theo:

> I hope I have landed on my feet this time, you know — yellow outside, white inside, with all the sun, so that I shall see my canvases in a bright interior — the floor is red brick; outside, the garden of the square, of which you will find two more drawings. (Letter 480)

He planned to "furnish the bedroom" and "put some Japanese things up on the wall" (Letter 480). He could have people come to sit for portraits (Letter 481). By May 10 he had "bought things for making a little coffee and soup at home, and two chairs and a table" (Letter 485). He had them repaint the house, the doors, and the windows (Letter 491).

In Vincent's mind, the Yellow House as refuge for struggling artists could be conceived as a monastery, where artists would live and work as simply as monks, with Gauguin as their abbot.

Vincent described for Bernard his plan to decorate the house "with a half a dozen pictures of 'Sunflowers,' ...effects like those of stained-glass windows in a Catholic church" (Letter B15). Early in September Theo sent three hundred francs and Vincent bought two beds, twelve chairs, a table, and a mirror. His joy is obvious. On September 8, he wrote in high spirits:

> ...a home of my own, which frees the mind from the dismal feeling of being a homeless wanderer. That is nothing when you are an adventurer of twenty, but it is bad when you have turned thirty-five. (Letter 533)

The following day, he wrote from a table at the "Night Café," where he had been spending his nights. He reports that he is "busy furnishing the house," the studio will "have a feeling of Daumier about it," and "Japanese things" and "ordinary lithographs by modern artists" will hang on its walls. Vincent intended "to buy something for the house every month." He might decorate his wooden bed with the painting of a child in a cradle. Theo, he wrote, can feel he has a "country house in Arles," and Vincent is making of it "really an artist's house." The house had become for him an exciting work of art itself. It was to be his refuge during his campaign of discovery in Provence:

> As for the house, the thought that it's going to be habitable continues to soothe me. Will my work really be worse because by staying in the same place, I shall see the seasons pass and repass over the same subjects, seeing again the same orchards in the spring, the same fields of wheat in summer? Involuntarily I shall see my work cut out for me beforehand, and I shall be better able to make plans. Then if I keep some studies here to make a coherent whole, it will mean work of a deeper calm at the end of a certain time. (Letter 535)

Vincent had bigger hopes for the Yellow House. From the outset he had dreamed of sharing the space. Theo's support could encourage other artists and bring Theo a more promising return on his investment. In the letter sent to Theo on his birthday, Vincent wrote, "Perhaps Gauguin will come south?" (Letter 480).

By September, the importance of Gauguin joining him at the Yellow House, the beginning of an association of artists forming a studio of the South, had become of critical importance:

> Do you realize that if we get Gauguin, we are at the beginning of a very great thing, which will open a new era for us?... *Gauguin's fare comes before everything else*, to the detriment of your pocket and mine. *Before everything else*. All the expenses I have mentioned are only meant to make a good impression on him at the moment he arrives. (Letter 544)

Vincent wrote to Gauguin, who was painting in Brittany, in October:

> I keep thinking incessantly of that plan to found a studio, which will have you and myself as permanent residents, but which the two of us would turn into a refuge and place of shelter for comrades at moments when they are encountering a setback in their struggle. (Letter 544a)

Vincent's "gospel for the poor" was now directed to the poor artists of his time. He went on to Gauguin:

I think that if, from now on, you begin to feel like the head of the studio, which we shall try to turn into a refuge for many,... then you will feel more or less comforted after the present miseries of poverty and illness, taking into consideration that probably we shall be giving our lives for a generation of painters that will last a long while. (Letter 544a)

In that same letter Vincent described a self-portrait he had done in which he "aimed at the character of a simple bonze worshiping the Eternal Buddha." In Vincent's mind, the Yellow House as refuge for struggling artists could be conceived as a monastery, where artists would live and work as simply as monks, with Gauguin as their abbot.

But Vincent assumed that Gauguin shared his own altruistic dream. This did not fit Gauguin's character. Gauguin, in financial difficulties, provisionally accepted Theo's money and Vincent's companionship in hopes of making sales enough through Theo to finance his own future plans, which did not include either Provence or a house of refuge for others. When Gauguin arrived at the Yellow House on October 23, 1888, he was already plotting his next move. After just two months, Gauguin left the Yellow House on December 26, 1888, and traveled by train to Paris. Vincent's ear-cutting incident, judged by physicians of the day to be related to the first of his epileptic attacks, occurred at this time.[33]

The failure of Vincent's dream had grave repercussions. Vincent later remembered the tension of his last

days with Gauguin: "I saw one thing only, that he was working with his mind divided between his desire to go to Paris to carry out his plans, and his life in Arles" (Letter 572). How much these tensions contributed to Vincent's illness can only be guessed. But the departure of Gauguin and the loss of the Yellow House during Vincent's illness were certainly crushing blows. While Vincent was hospitalized, flood waters came almost to the door of his studio and the walls oozed with water. Paintings he had sacrificed himself to create were damaged or destroyed. In a poignant letter sent for Theo's next birthday, one year from the letter that announced the renting of the Yellow House, Vincent lamented:

> That touched me to the quick, not only the studio wrecked, but even the studies which would have been a souvenir of it ruined; it is so final, and my enthusiasm to found something very simple but lasting was so strong. It was a fight against the inevitable, or rather it was weakness of character on my part, for I am left with feelings of profound remorse, difficult to describe. I think that was the reason why I have cried out so much during my attacks, it was because I wanted to defend myself and could not do it. For it was not for myself, it was for painters like the unfortunates... that that studio would have been of some use. (Letter 588)

Vincent's simple painting of his bedroom in the Yellow House was not so simple after all. A dream died with the loss of that home. Vincent, like the Suffering Servant of

A Painting of Nothing at All

Isaiah, had suffered to bring healing to others, but he saw his sacrifices come to nothing.

From the perspective more than a century allows, we still marvel at the work salvaged from what Vincent called his "shipwrecked studio." But even more miraculous is Vincent's resilience. He went on to create over a hundred more masterpieces. From his next bedroom, a barred cell in the asylum in Saint-Rémy, he created *Starry Night*, a series of wheatfields with sowers and reapers, olive orchards, cypresses, and almond blossoms. He was surrounded at night, he tells us, by the "cries and howls" of disturbed inmates. His final room in the village of Auvers was a hot, windowless attic. In the seventy days he lived there he created seventy more paintings, including the Auvers church, great fields of wheat under stormy skies, and the portrait of Dr. Gachet.

> *Personally I believe that the adversities one meets with in the ordinary course of life do us as much good as harm.*

Books, paintings, and nature were among the resources that had enriched Vincent most of his life; they now helped him endure. In the Arles hospital, he reread Harriet Beecher Stowe's *Uncle Tom's Cabin* and the Christmas books of Dickens (Letter 582), and soon after his arrival at the asylum, he reread the works of Shakespeare (Letter 597). In April 1889, just before entering the asylum, he wrote Wilhelmina that the memory of works by

Voltaire and Flaubert "often sustains me in the hours and days and nights that are hardly easy or enviable" (Letter W11). And he meditated on the artists he admired. He told Theo, "Let us remember that in our time we have loved Millet, Breton, Israels, Whistler, Delacroix and Leys" (Letter 590).

Vincent's love of nature also offered strength and called him back to his work. While recounting the most devastating details of failure and illness, Vincent breaks into ecstatic descriptions of moments in nature: "Oh, my dear Theo, if you saw the olives just now.... the rustle of an olive grove has something very secret in it" (Letter 587). From his cell at the asylum he wrote:

> But what a lovely country, and what lovely blue and what a sun! And yet I have only seen the garden and what I can look at through my window.
>
> (Letter 593)

Vincent's parsonage days and devoted reading of the Bible had prepared him for a life of sacrifice and suffering. But now even his plans for sacrifice had to be sacrificed. The abandonment of cherished ambitions for the future of art led him to even deeper levels of renunciation. He wrote to Theo:

> It is just in learning to suffer without complaint, in learning to look on pain without repugnance, that you risk vertigo, and yet it is possible, yet you may catch a glimpse of a vague likelihood that on the other side of life we shall see good reason for the

existence of pain, which seen from here sometimes so fills the horizon that it takes on the proportions of a hopeless deluge. (Letter 597)

From the asylum, Vincent wrote to Mrs. Ginoux, the wife of the proprietor of the "Night Café," who also suffered a difficult illness:

> Personally I believe that the adversities one meets with in the ordinary course of life do us as much good as harm. The very complaint that makes one ill today, overwhelming one with discouragement, that same thing — once the disease has passed off — gives us the energy to get up and want to be completely recovered tomorrow.... Diseases exist to remind us that we are not made of wood, and it seems to me this is the bright side of it all.
>
> And after that one dreams of taking up one's daily work again, being less afraid of obstacles, with a new stock of serenity. (Letter 622a)

During his crisis, Vincent particularly turned to thoughts of all Theo had done for him. He told him, "If I were without your friendship, they would remorselessly drive me to suicide" (Letter 588). His feelings regarding his brother's friendship moved him so deeply that he could scarcely find words to communicate them:

> Do not be grieved at all this. Certainly these last days were sad, with all the moving, taking away all my furniture, packing up the canvases that are going to you, but the thing I felt saddest about was

that you had given me all these things with such brotherly love, and that for so many years you were always the one who supported me, and then to be obliged to come back and tell you this sorry tale — But it's difficult to express it as I felt it. The goodness you have shown me is not lost, because you had it and it remains for you; even if the material results should be nil, it remains for you all the more; but I can't say it as I felt it. (Letter 585)

Some months later Vincent asked Theo to send the damaged painting of the Yellow House's bedroom to the asylum so that he might repaint it:

> At first I had wished to have it recanvased because I did not think I could do it again. But as my brain has grown calmer since, I can quite well do it again now.
> The thing is that among the number of things you make, there are always some that you felt more or put more into and that you want to keep in spite of everything. (Letter 594)

The moment of gratitude when Vincent painted his bedroom in thanks for the rest it had provided, and his wish to preserve that memory of his dream of a refuge for artists in need, infinitely deepen our own feelings for that painting of "nothing at all."

NINE

La Berceuse
The Mystery of the Missing Cradle

Every day I visited the Metropolitan Museum during my stay in New York, I reserved time for the gallery holding the Annenberg collection and its wonderful van Gogh paintings. As if waiting to resume our conversation of the previous day was Augustine Roulin, mother of three, wife of Vincent's best friend in Arles, Joseph the postman. From a distance it appeared that she was watching for me, but when I was directly in front of her it became clear that she was in a meditative reverie. Her blue-green eyes were looking within, perhaps focused on some event of the past, or on the future of her children, Armand, Camille, and baby Marcelle.

Vincent had set up his easel in her home near the railroad bridge, just a block or two behind his Yellow House. He saw before him a strong wife and mother in her rocking chair, a peasant of Provence pondering her life. The eccentric painter intended to paint everyone in her family; he had already had her husband come in his postal uniform to be painted in his studio. Vincent described his friend to Theo and joked that although

La Berceuse. Arles, February 1889. F507, JH1672, oil on canvas, 35⅞ x 28⅜". Vincent van Gogh Foundation, Stedelijk Museum, Amsterdam.

Joseph accepted no pay for posing, he "cost me more eating and drinking with me" (Letter 518).

Augustine's life likely followed the pattern of many housewives of the south of France. She was born in 1851, two years before Vincent, and she would outlive him by forty years, dying at age seventy-nine in 1930. She had married Joseph, ten years her senior, in 1868, when she was just a girl of seventeen. Three years later her son, Armand, was born. As she sat in her rocker, she may have been musing on Armand's good fortune to be apprenticed to a blacksmith. He'd always be able to make a living for himself, and perhaps for a wife and children of his own. Perhaps she was imagining what the future held for her eleven-year-old Camille, or her new baby girl, Marcelle. How would the family manage on Joseph's salary with a third child?

Her husband Joseph was an open, friendly man, who had little patience with institutions, including the church. Vincent enjoyed describing for his sister, Wilhelmina, the events following the birth of Marcelle:

> The father has refused to have it baptized — he is an ardent revolutionary — and when the family grumbled, possibly on account of the christening feast, he told them the christening feast would take place nonetheless, and that he would baptize the child himself. Then he sang the "Marseillaise," in a frightful voice. (Letter W6)

The postman earned only about 150 francs a month, less than Theo provided for Vincent's room, board, and

painting needs, and Joseph had a family of five to support. By the time Vincent left Arles, Joseph Roulin had been transferred to Marseilles at a slight pay raise, but the moving expenses were such that he had to leave his family behind for a time. Perhaps the impending transfer and separation were on Augustine's mind that day Vincent painted her. Joseph died in Marseilles in 1903, fifteen years after Vincent painted Augustine's reverie in that rocking chair. She would outlive Joseph by twenty-seven years.

As I stand before her portrait, I try to reconstruct those days when Vincent felt so close to the Roulin family. I tell her, "Vincent thought this painting of you so important, he painted it five times. He offered you one of the paintings, and this is the image you chose. Vincent said you had a good eye, you chose the best he had done. I wonder whether this painting hung in your new home in Marseilles, whether you ever looked at it and remembered that strange Dutch artist. Did you remember the day when news reached your family that he had died? Perhaps you remembered that you were thirty-seven when he painted you, the very age at which he died. I wonder whether you made enough money to pay your bills when you sold the painting to a traveling art dealer searching for van Gogh's works."

I ask my questions, but Augustine remains in that reverie of a century ago. I recall the unusual plans Vincent had for this work that took his most intense energy and imagination, and that may have brought on one of his attacks. He painted Augustine Roulin, but deeper

doors of symbolic meaning had been opening in his soul. In the autumn of 1888 he had described for Theo his dream of a new sort of portrait:

> And in a picture I want to say something comforting, as music is comforting. I want to paint men and women with that something of the eternal which the halo used to symbolize, and which we seek to convey by the actual radiance and vibration of our coloring. (Letter 531)

Vincent sought to display the sainthood of ordinary peasants and workers. The wife of his friend Joseph, that caring mother of three, provided him such an opportunity. He painted her several times, and meant her to be the central panel of a triptych, a presentation normally used on altars with sacred scenes and the figures of saints. He explained that he would like a sunflower painting on either side of her as "candelabra" (Letter 574).

But Vincent's plans for *La Berceuse* could be even stranger. He had read Pierre Loti's popular sea novel *Pêcheur d'Islande* (*An Iceland Fisherman*) and had expressed great sympathy for the fishermen who faced the dangers of the sea daily to feed their families. The novel opens with a description of the fishermen and of the shrine to the Virgin Mary, patron saint of fishermen, that hung on the ship's cabin wall:

> They had been drinking wine and cider in their pannikins, and the sheer enjoyment of life lit up their

frank, honest faces. Now they lingered at table chatting, in Breton tongue, on women and marriage. A china statuette of the Virgin Mary was fastened on a bracket against the midship partition, in the place of honor. The patron saint of our sailors was rather antiquated, and painted with very simple art; yet these porcelain images live much longer than real men, and her red and blue robe still seemed very fresh in the midst of the somber grays of the poor wooden box. She must have listened to many an ardent prayer in deadly hours; at her feet were nailed two nosegays of artificial flowers and a rosary.[34]

That Vincent associated his painting of Augustine Roulin, surrounded by flowering wallpaper and holding a rope, with this image of the Virgin with flowers and rosary becomes clear as he writes Theo:

> I have just said to Gauguin that following those intimate talks of ours the idea came to me to paint a picture in such a way that sailors, who are at once children and martyrs, seeing it in the cabin of their Icelandic fishing boat, would feel the old sense of being rocked come over them and remember their lullabies. (Letter 574)

Imagine the scene as Vincent saw it. The sailors in their hammocks or at their posts during a storm sway back and forth with the roll of the waves. They look to the cabin wall to pray, and see the portrait of Augustine Roulin in her rocking chair. The reds and oranges and

greens of Vincent's painting vibrate like a luminous halo around this ordinary woman, this modern saint. The rope she holds leads to their hammocks or to their boat, their "cradle." They remember their mothers, the care they received as infants, and the rocking boat is made holy and safe as was once their cradle in mother's care.

> *I need not rush myself too much — there is no good in that, but I must work on in complete calmness and serenity.*

The word clue Vincent painted in red on red was important, yet not immediately obvious to the viewer. There near Augustine's left elbow are the words "La Berceuse," the cradle-rocker. If the theme of this painting is a mother rocking a cradle, where is the cradle? Vincent draws the viewer to look at the breadth of Augustine's lap covered by her green skirt, then to her crossed hands, and finally up to her peaceful face. There is no cradle in the painting because the artist has placed the viewer in the cradle, looking up at Mother. The rope she holds as she rocks, rocks the cradle. Viewer and cradle-rocker are bound together by this cord of loving care. Mother and child are celebrated together. Gratitude for birth and nurture complete the experience. We are brought back to those early letters celebrating the cradle as a place for meditation, a place where the "ray from on high" can be found (Letter 242).

I step back as two women come to view the painting. It holds their attention for some minutes. I hear one brief exchange: "What does her shape tell you, Mom?" Mom answers, "You must be thinking what I am. Her breasts are large with milk. And that blouse is made so it can open to feed her baby."

Vincent had been away from Holland for some years, a stranger with few friends, living the lonely life of an artist who hikes into the countryside and spends most of his days alone at an easel. His thoughts easily moved from the Roulin family to his own childhood. He writes Theo that "as a married couple our parents were exemplary, like Roulin and his wife." He advises Theo, who has revealed his plans to marry, to "take the same road." Vincent then tells him of the images that came to him during the illness that he suffered as he was painting La Berceuse:

> I saw again every room in the house at Zundert, every path, every plant in the garden, the views of the fields outside, the neighbors, the graveyard, the church, our kitchen garden at the back — down to the magpie's nest in a tall acacia in the graveyard.
>
> It's because I still have earlier recollections of those first days than any of the rest of you. There is no one else who remembers all this but mother and me.
>
> I say no more about it, since I had better not try to go over all that passed through my head then.
>
> (Letter 573)

Vincent's memories of "mother and me" at his birthplace in Zundert, Holland, and his painting of a mother

rocking the cradle in the Roulin household moved him too deeply for words. *La Berceuse* forms a central panel in the memory of Vincent van Gogh.

Early in his painting career, Vincent had wondered how many years he could count on to complete his work as painter. He told Theo: "Not only did I begin drawing relatively late in life, but it may also be that I shall not live for so very many years." He guessed that perhaps he had "between six and ten" years left:

> I need not rush myself too much — there is no good in that, but I must work on in complete calmness and serenity, as regularly and fixedly as possible, as concisely and pointedly as possible. The world concerns me only in so far as I feel a certain indebtedness and duty toward it because I have walked this earth for thirty years, and out of gratitude, want to leave some souvenir in the shape of drawings or pictures — not made to please a certain taste in art, but to express a sincere human feeling. (Letter 309)

At the very moment he was painting the deep serenity of Madame Roulin tending a cradle, Vincent was about to be visited with an illness that would frighten and confuse him for the rest of his brief life. But this could not erase the memories he shared with his mother and his friendship with another mother, Augustine Roulin. We would never know the Roulin family apart from their hospitality to Vincent and his response in painting a contemporary saint, "La Berceuse."

TEN

Starry Sky
Splendors of the Night

I had driven from Arles to Saint-Rémy, a half-hour to the northeast, along narrow, shaded roads through columns of sycamore trees. Everywhere there were orchards and fields of lavender and thyme. On the town's outskirts I found the site of the Roman settlement of Glanum, and just across the road were olive groves and the asylum called Saint-Paul-de-Mausole. Vincent had taken the train from Arles to Saint-Rémy, accompanied by a local pastor, the Reverend Salles. He voluntarily admitted himself to the asylum on May 8, 1889.[35]

I followed the long walkway to the asylum's vestibule, which Vincent had drawn in chalk and gouache. Saint-Paul-de-Mausole was to be his home for over a year. He left on May 18, 1890, to visit Theo, Johanna, and his godchild in Paris. Four days later he moved into an attic room in Auvers, northwest of Paris, where he died in late July. I walked the shaded cloisters, listening to the sounds of the current patients moving behind the heavy wooden doors. I hiked the surrounding countryside. The twisted forms of the olive trees, their silvery

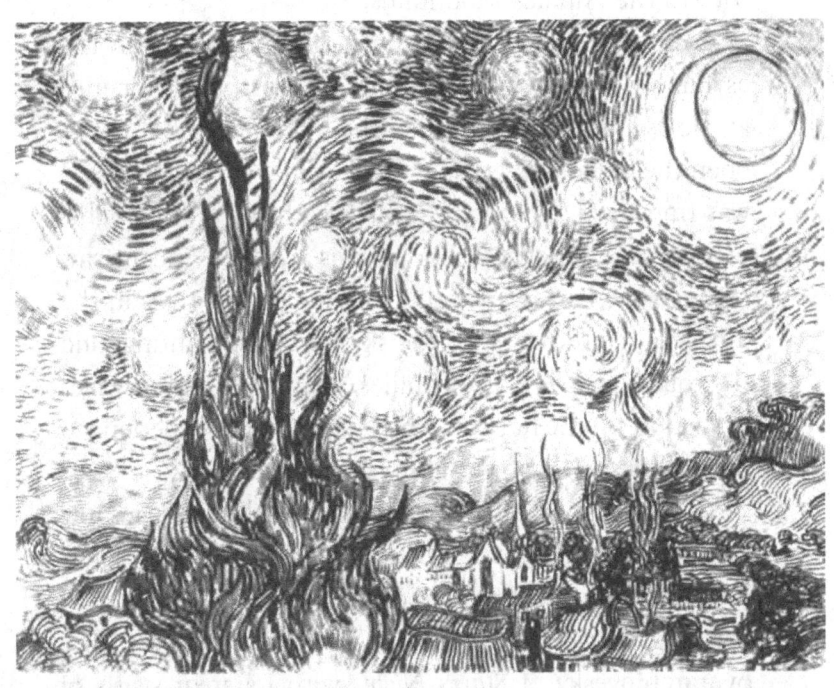

Starry Night. Destroyed? Formerly Kunsthalle, Bremen, June 1889. F1540, JH1732, pen drawing after the oil painting (F612, JH1731), 18½ x 24¾".

leaves reflecting the sun, and the buzz of cicadas reminded me of Vincent's paintings of olive groves and drawings of cicadas. I walked cautiously around the pits and ravines where once were ancient quarries stretching toward the Alpilles Mountains.

I settled in the second-floor room of an inn near the asylum, with my window facing southeast, like Vincent's at the asylum. I awoke during the night and rose to push open the casement window to allow in a cooling breeze. I was transfixed. The sky was filled with the pulsing lights of stars and a gigantic moon. This is what Vincent saw through the bars of his cell window. Cypress trees in the inn's courtyard rose into the sky, as in his painting, and the rolling shapes of the Alpilles Mountains added waves of shadow on the horizon. I had never before experienced the sky as such a powerful presence.

Vincent van Gogh thought of himself as a peasant-painter following in the footsteps of his artist-hero, Jean-François Millet, but people often pass over his scores of paintings of peasants and focus on his *Starry Night*. The overarching sky of *Starry Night*, with its great swirls of moon and starlight, is found on coffee mugs, calendars, T-shirts, jewelry, posters, puzzles, book covers, umbrellas, and night lights.

Vincent wrote Theo in June 1889, "I have a landscape with olive trees and also a new study of a starry sky" (Letter 595). Nine months earlier in Arles he had painted a starry night over a curve of the Rhone River, with brilliant stars and city lights reflecting in the river.

And before that, he painted his friend Eugene Boch, a Belgian painter, against an imaginary night sky:

> Behind the head, instead of painting the ordinary wall of the mean room, I paint infinity, a plain background of the richest, intensest blue that I can contrive, and by this simple combination of the bright head against the rich blue background, I get a mysterious effect, like a star in the depths of an azure sky. (Letter 520)

When Theo received the painting we call *Starry Night*, he barely mentioned the sky and made no mention of the stars. He wrote Vincent:

> I understand quite well what it is which preoccupies you in your new canvases, like the village in the moonlight, or the mountains, but I think that the search for some style is prejudicial to the true sentiment of things. (Letter T19)

It is remarkable that Theo's tone is rather negative. Perhaps he was concerned about Vincent's mental health and the obvious over-excitement the painting reveals. It is possible that his response was intended to deflect Vincent from such vertiginous visions.

In *Van Gogh in Saint-Rémy and Auvers* Ronald Pickvance notes that various commentators have suggested such influences on the painting's symbolism as Genesis and the Book of Revelation, the American poets Whitman and Longfellow, and the writers Zola, Daudet, Dickens, and Carlyle.[36] Certainly Vincent knew these

works, and his painting may show some of their influence. But to my mind, these pass over the most obvious source, an artist whose works and words were much on Vincent's mind during his days in the asylum. Vincent would, in fact, soon be copying many of the works of that artist, Jean-François Millet, and his name comes up in letter after letter during that period.

> *When shall I paint my starry night, that picture which preoccupies me continuously?*

Alfred Sensier's biography of his friend Millet was a sort of scripture to Vincent, and there he would have read of Millet's powerful interest in the night sky. Commenting on the many paintings Millet had done of shepherds, Sensier wrote:

> The shepherd is not a countryman after the pattern of the laborers and other field-hands; he is an enigma, a mystery.... Besides he is a man of contemplation. He knows the stars, watches the sky, and predicts the weather.... This solitary being greatly interested Millet.[37]

In relation to one painting of a shepherd at night, Sensier quotes Millet's words:

> Oh, how I wish I could make those who see my work feel the splendors of the night! One ought to be able to make people hear the songs, the silences

and murmurings of the air. They should feel the infinite. Is there not something terrible in thinking of these lights which rise and disappear, century after century, without varying? They light both the joys and sorrows of men, and when our world goes to pieces, the beneficent sun will watch without pity the universal desolation.[38]

I have on my desk Griselda Pollock's book *Millet*.[39] A full page in color is devoted to Millet's oil painting titled *Starry Night*, done some twenty years before Vincent decided to become an artist. The lower half of the painting is a dark country scene with an earthen road, bushes, and a shadowy outline of trees against a fantastic sky, with the faint glow of the setting sun at the horizon. Above that glow are the blues and greens and golds of a sky alive with white stars of various sizes and the arcs of meteors. Vincent probably saw that painting at a sale of Millet's work in Paris.

Millet's words, "Oh, how I wish I could make those who see my work feel the splendors of the night," would have been enough to cause Vincent to do such a painting himself, especially during his stay at the asylum, where he watched the sky through the bars of his window during the long nights.

Second to the influence of Millet, I would select Walt Whitman. Vincent wrote his youngest sister, Wilhelmina, in 1888:

Have you read the American poems by Whitman? He sees in the future, and even in the present, a

world of healthy, carnal love, strong and frank — of friendship — of work — under the great starlit vault of heaven a something which after all one can only call God — and eternity in its place above the world. (Letter W8)

Vincent sees several of his own chief themes in Whitman, including what he described as "something which after all one can only call God." What we might call a creation theology that brings our ordinary pursuits on earth into relation with the expanse of the heavens emerges in Vincent's work, as it did in the songs of Whitman. Vincent calls attention to Whitman's poem "Prayer of Columbus" and describes it as "very beautiful." Columbus is portrayed late in life, recounting his struggles, doubts, and accomplishments, not unlike Vincent's musings in the asylum. Columbus tells of "Heavens whispering to me" and "hemispheres rounded and tied, the unknown to the known." He concludes:

> And these things I see suddenly, what mean they?
> As if some miracle, some hand divine unseal'd my
> eyes,
> Shadowy vast shapes smile through the air and
> sky.[40]

Vincent may also have read Whitman's famous poem of 1867, "When I Heard the Learn'd Astronomer," which contrasts a scholar's lecture on astronomy with the poet's response:

Till rising and gliding out I wandered off by myself,
In the mystical moist night-air, and from time to time
Look'd up in perfect silence at the stars.[41]

Vincent's situation at the asylum was more poignant. Unable to rise and glide outdoors, he leaned against the barred window of his cell to look up at the heavens, and invited us ever after to share his ecstatic experience of exaltation and liberation in the presence of the infinite.

> *Life too is probably round, and very superior in expanse and capacity to the hemisphere we know at present.*

That Vincent longed to paint a starry night is made clear in his letters. Something of the symbolic associations he felt in his paintings of nature and the need for a starry sky are expressed to Bernard in a letter from Arles in the spring of 1888:

> I am still charmed by the magic of hosts of memories of the past, of a longing for the infinite, of which the sower, the sheaf are the symbols — just as much as before. But when shall I paint my starry night, that picture which preoccupies me continuously?
>
> (Letter B7)

Imagery of the heavens and the infinite continued on Vincent's mind and appear in several letters to Bernard. The very next letter, for example, likely from the end

of June 1888, reveals that the stars and planets represented Vincent's future hopes and the possibility of transformation after death:

> But seeing that nothing opposes it — supposing that there are also lines and forms as well as colors on the other innumerable planets and suns — it would remain praiseworthy of us to maintain a certain serenity with regard to the possibilities of painting under superior and changed conditions of existence, an existence changed by a phenomenon no queerer and no more surprising than the transformation of the caterpillar into a butterfly....
>
> The existence of painter-butterfly would have for its field of action one of the innumerable heavenly bodies, which would perhaps be no more inaccessible to us, after death, than the black dots which symbolize towns and villages on geographical maps.
>
> (Letter B8)

Vincent sought truth incarnate in the ordinary things of the earth, but when difficulties surrounded him in the work at hand, he had available the more dangerous but direct exaltation of the heavens, the night sky laden with symbols of the infinite. So in the midst of difficult paintings of the things around him, he wrote to Theo:

> And it does me good to do difficult things. That does not prevent me from having a terrible need of — shall I say the word? — of religion. Then I go out at night to paint the stars. (Letter 543)

Splendors of the Night

That the stars might be painted as a doorway to the infinite seems of special importance to Vincent. Discovering a sort of natural symbolism shared by all humans was one of his goals as artist. His creation theology was also a theology of natural symbols available to all. He expressed his search this way to Theo:

> I am always in hope of making a discovery there, to express the love of two lovers by a wedding of two complementary colors, their mingling and their opposition, the mysterious vibration of kindred tones....
>
> To express hope by some star, the eagerness of a soul by a sunset radiance. Certainly there is no delusive realism in that, but isn't it something that actually exists? (Letter 531)

Vincent's work of imaginative discovery reached a culmination in *Starry Night*, expressing the waves of motion and emotion that link the overarching sky with hopes of future transformation on earth. He began his work as artist by drawing the miner germinating deep in the earth. He concluded a major phase of his work with the luminous sky under which the village, the cypress, and the church spire find meaning. Between earth and heaven the poet and painter struggle to discover what is beyond and what is within that give life its significance. He wrote Bernard:

> The earth has been thought to be flat.... Which, however does not prevent science from proving the earth is principally round.

> But not withstanding this they persist in believing that life is flat and runs from birth to death. However life too is probably round, and very superior in expanse and capacity to the hemisphere we know at present. (Letter B8)

Perhaps this "spherical" view is at the heart of the vibrations in Vincent's *Starry Night*. Perhaps he stretched his imaginative powers to the breaking point in this work, creating one of his most "musical" paintings. But the strain may have been too great for him to continue in this direction; earth seems to have called him back. Had Vincent continued in the direction of *Starry Night* he may have become the first abstract expressionist. But there was other work all around him that called to be finished. He later reassured his worried brother that rather than "dropping reality and making a kind of music of tones with color," he would return to being a "shoemaker" (Letter 626). Returning to the commonest things on earth, he wrote Theo:

> Only I have no news to tell you, for the days are all the same, I have no ideas, except to think that a field of wheat or a cypress is well worth the trouble of looking at close up. (Letter 596)

His return to his work in nature was to be a journey through olive orchards and cypresses, almond branches and poppies, fields of ripe wheat under stormy skies. Moses experienced ecstasy at a burning bush, only to return to a contest with Pharaoh, to wandering in the

wilderness, and to a lonely death on Mount Nebo; Vincent's experience of a burning night sky and subsequent journey to a lonely hillside and empty pathways and death in Auvers is comparable. Their ecstatic visions may have remained with each forever, but they both returned to a life of suffering, disappointment, and sacrifice.

ELEVEN

First Steps
A Family Sacrament

I am in the garden of the Cooper-Hewitt Museum, on Fifth Avenue's "Museum Mile," not far from the Metropolitan Museum of Art. I spent the morning with a van Gogh painting in the Metropolitan and then walked here to be in this corner of nature for my lunch. It is the Fourth of July, and the only other person sitting in this garden is a young Japanese woman. The garden is green and wet from a morning rain, a few golden lilies, gray stones, green tables, and silver chairs. The Japanese woman reads a tour book of New York City, her brown umbrella handle hooked to her table. I carry a sandwich and coffee from the small museum snack shop to my table, and a sparrow soon joins me for a few crumbs. It is very quiet and very beautiful.

My morning was spent in a gallery at the Metropolitan that holds works by van Gogh and friends. On one wall are Vincent's irises in a vase, a cypress Vincent described as "beautiful as an Egyptian obelisk," a vase of oleander blossoms with two books, and a painting of drying sunflowers. Paintings by Gauguin, Seurat, and

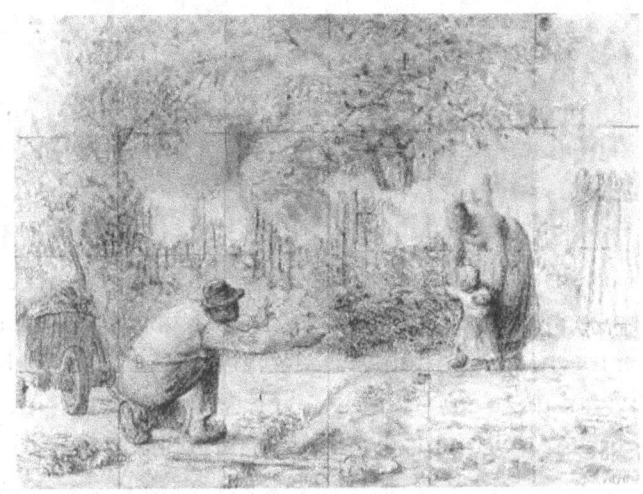

First Steps. Saint-Rémy, January 1890. Black-and-white photograph of Millet's *First Steps*, to which Vincent added a grid to aid him in copying; the photo with grid is in the Van Gogh Museum, Amsterdam. The image below is Vincent's oil painting *First Steps*, his "copy" of the Millet drawing. Vincent explained, "It is translating — into another language — that of color" (Letter 623).

First Steps. Saint-Rémy, February 1890. F668, JH 1883, 28½ x 35⅞". Metropolitan Museum of Art, New York City.

Toulouse-Lautrec complete the room. But I have omitted mentioning the canvas that held my attention all morning.

Among the people in the gallery was a woman in the blue-gray uniform of a gallery attendant. She was watching me, and her look seemed to invite a question, and so I approached her: "You must spend a lot of time in this gallery; is there any painting that has become a favorite?" She seemed pleased to be asked, and replied:

> I have children. One painting here is for a children's room I think. It is beautiful. Children and parents who come to this gallery love it best. Watch that entrance that is near the elevator and you will see parents with strollers coming into the gallery with their children. Watch where they go and you will discover my favorite painting.

She was enjoying making a game of my search for her favorite painting. I took her advice and watched. A mother pushing a stroller entered the gallery. She looked around and then headed directly to one painting. She lifted her son from the stroller, pointing and talking to him about what he was seeing. A minute later a French couple entered with a daughter about age seven. They viewed several paintings, but stopped in front of that same work. The daughter apparently wanted the card beside the painting read to her. She opened her journal and began to make a sketch. I looked at the attendant and she smiled: "Of course that is my favorite painting."

A Family Sacrament

I hadn't focused on that work before because I knew it was Vincent's copy of another artist's work. But now I could see it as a favorite of children. It is Vincent's copy in oils of Millet's drawing *First Steps*. Vincent had likely seen the drawing in a Millet exhibition in Paris, and again in Sensier's biography. A photo of Millet's drawing sent by Theo to Vincent is in Amsterdam's Van Gogh Museum. A grid drawn over the photo was intended by Vincent to help him create his copy.[42]

Unlike many of Vincent's works done in bright, jarring colors, this painting is in soft blues and greens with white, yellow, and a touch of tan and orange. It has a feeling of serenity and a cool, refreshing breeze. It takes us into a garden just outside a peasant family's thatched-roof home. There is a wooden fence beside the simple home and a wooden gate held closed by the loop of a rope. A peasant woman in blue, her golden hair pinned close to her head, leans forward, steadying the year-old child in front of her. The small child reaches out toward the father, who kneels to the left of the garden, his arms outstretched toward the child. A brimmed hat of orange shades his face.

We are invited to share in the most simple of dramas, a sacrament common to families, baby's first steps. No wonder children and parents who enter the gallery stop and smile at that scene. They share the moment with each other and with the French peasant family of a century ago.

What are we to make of Vincent's copying the work of another artist? Beginners often learn by copying masterworks of great artists. So Vincent, in 1880, labored over

a copy-book called *Cours de Dessin Bargue* and a variety of photos and prints he owned or borrowed. Even when Vincent was a beginner, Millet was a favorite. Vincent wrote Theo that he was "trying to sketch large drawings after Millet" (Letter 134). In that same letter he asked Theo to send him copies of Millet's *The Four Hours of the Day* and *The Labors of the Fields*. By the following letter he reported, "I have sketched the ten sheets of 'The Labors of the Fields' and I have already drawn 'The Sower' five times, twice in small size, three times in large, and I will take it up again, I am so entirely absorbed in that figure" (Letter 135).[43]

Why did Vincent return to copying in the last year of his life, after entering the asylum of Saint-Rémy? He copied works by Gustave Doré, Honoré Daumier, Virginie Demond-Breton, two Rembrandts, three Delacroix works, and twenty by Millet.

It began by accident. During an attack of illness, Vincent dropped a lithograph of Delacroix's *Pieta* into some paint and decided to replace it by copying it in oils. This copy led to almost thirty others. When he began copying Millet's drawings of peasants at work, he explained to Theo:

> I am going to try to tell you what I am seeking in it and why it seems good to me to copy them. We painters are always asked to *compose* ourselves and *be nothing but* composers.
>
> So be it — but it isn't like that in music — and if some person or other plays Beethoven, he adds his

personal interpretation — in music and more especially in singing — the interpretation of a composer is something, and it is not a hard and fast rule that only the composer should play his own composition.

Very good — and I, mostly because I am ill at present, I am trying to do something to console myself, for my own pleasure.

I let the black-and-white by Delacroix or Millet or something made after their work pose for me as a subject.

And then I improvise color on it, not, you understand, altogether myself, but searching for memories of *their* pictures — ...

Many people do not copy, many others do — I started on it accidentally, and I find that it teaches me things, and above all it sometimes gives me consolation. And then my brush goes between my fingers as a bow would on a violin, and absolutely for my own pleasure. (Letter 607)

We can feel the sense of relief and pleasure he got from interpreting the works of artists he loved and admired. He noted also that he is copying "because I am ill," which suggests the massive energy required to create original works. He hiked many miles searching for scenes that "spoke to him." After a campaign of painting he was often so exhausted in body and mind that he fell into bed for several days.

But he struggled over the issue of copying:

> I think that there is justification for trying to reproduce some of Millet's things which he himself had no time to paint in oil. Working thus on his drawings or on his woodcuts is not purely and simply copying. Rather it is translating — into another language — that of color —. (Letter 623)

He also told Wilhelmina:

> I don't especially like to see my own pictures in my bedroom, which is why I copied one picture by Delacroix and some others by Millet.
> (Letter W14)

Theo had sent him more photos and etchings of works by Millet, but Vincent decided to cease his copying:

> I have scruples of conscience about doing the things by Millet which you sent me.... I took the pile of photographs and unhesitatingly sent them to Russell so that I shall not see them again until I have made up my mind. (Letter 625)

He then admits to "a fear lest it should be plagiarizing" and notes that "my illness makes me very sensitive now, and for the moment I do not feel capable of continuing these 'translations' when it concerns such masterpieces. I am stopping at the 'Sower'" (Letter 625).

And so the strange and fascinating period of "translations" ended abruptly. Vincent's copies gave him great pleasure at a time of illness and seclusion, and we can

A Family Sacrament

appreciate them for that. But they also witness to Vincent's sense of himself as one link in a chain of painters owing much to the masters before them.

> *Some tell me that I deny the charms of the country. I find much more than charms — I find infinite glories.*

Vincent felt a profound and intimate connection with the "peasant-painter" Jean-François Millet (1814–75), a man raised on a Normandy farm, who spent much of his life hidden in the village of Barbizon. Long before he had begun painting, Vincent had collected photos and etchings of Millet's work. In 1874, an art clerk in London, he wrote to the teenage Theo:

> Yes, that picture by Millet, "The Angelus," that is *it* — that is beauty, that is poetry. (Letter 13)

When he was sent to Paris, Vincent visited the exhibition of the deceased Millet's drawings and pastels. He reported to Theo:

> When I entered the hall at the Hotel Drouot, where they were exhibited, I felt like saying, "Take off your shoes, for the place where you are standing is Holy Ground." (Letter 29)

He was Vincent's ideal and inspiration. About the time Vincent was painting his own great peasant painting *The Potato Eaters*, he wrote Theo:

> I repeat, Millet is *father Millet* — that is, a guide and counselor to the younger painters in all things.
>
> (Letter 400)

In that same letter Vincent quotes words of Millet:

> I always think of what Millet said, "I would never do away with suffering, for it often is what makes artists express themselves most energetically."

When Vincent discovered a book entitled *La vie et l'oeuvre de J.-F. Millet* by Alfred Sensier, a rather romanticized and religious interpretation of the artist's life, with long quotations of Millet's words in personal conversation and letters, he shared the news of his discovery with Theo:

> Say, Theo, what a great man Millet was! I borrowed Sensier's great work from De Bock; it interests me so much that I wake up at night and light the lamp and sit up to read. (Letter 180)

The book offers clues to many of Vincent's aspirations, struggles, and especially the subjects of many of his paintings. For example, the cover of the original book was embossed with a sketch of a pair of empty shoes, the wooden "sabots" of a peasant laborer. When friends asked for some memento, Millet would draw for women a few stalks of wheat on a card, and for men a pair of empty sabots.[44]

Vincent identified with Millet's defense of his rough and honest views of nature and the peasant at labor.

He had faced criticism regarding his "ugly" portraits of peasants in *The Potato Eaters* and his "crude" manner of painting flowers and sun. Millet had written Sensier:

> Some tell me that I deny the charms of the country. I find much more than charms — I find infinite glories.... I see the halos of dandelions, and the sun.... But I see as well, in the plain, the steaming horses at work, and in a rocky place a man, all worn out.[45]

In *First Steps*, Millet and Vincent join hands to focus on a child in a peasant family. This is one of Millet's many paintings of children; he had a large family of his own. His six daughters inspired a number of works in which their mother teaches her daughters the household arts. For example, *The Knitting Lesson* in the Boston Museum of Fine Arts depicts a serene mother enveloping her daughter, guiding both tiny hands. He also painted family scenes including *Evening*, with a mother at her sewing and father weaving a basket, both close to their baby in its cradle. Vincent copied *Evening* in oils and sent it to Theo and his pregnant wife, Johanna. Theo's response was enthusiastic:

> One of the things I love the most is the "Evening" after Millet. Copied in a way that it isn't a copy. There is a clear tone in it and everything has been captured so well. It is a real success. (Letter T24)

As I view *First Steps*, I think of Vincent's brief time with the strange family he gathered around him in The

Hague. The prostitute's baby boy had been a joy to Vincent. He wrote of watching the baby in its crib and at play in his studio. Vincent was to lose the "borrowed" family that meant so much to him. Perhaps he was thinking of that loss when he copied Millet's *First Steps*, a moment in family life that bound together man, woman, and child in an act of nurturing love, an act that opens the way to the mystery of God.

Vincent had long believed

> the best way to know God is to love many things. Love a friend, a wife, something — whatever you like — you will be on the way to knowing more about him; that is what I say to myself. (Letter 121)

In all things, Vincent sought to put his beliefs into action. Love, labor, and service to the child and the sufferer were bound to express themselves. He was once asked by a friend, another Dutch painter, what his creed for life was. He responded:

> I want to be silent — and yet, because I *must* speak — well then — as it seems to me: to love and to be lovable — to live — to give life, to renew it, to restore it, to preserve it — and to work, giving a spark for a spark, and above all to be good, to be useful, to be helpful in something, for instance lighting a fire, giving a slice of bread and butter to a child, a glass of water to a sufferer. (Letter R4)

TWELVE

Wheatfield with Crows
A Harvest Hymn

Among the collection of seventy "Van Gogh's Van Goghs" on exhibit at the National Gallery of Art in Washington, D.C., was *Wheatfield with Crows*.[46] As I followed the long line of people past the Impressionist galleries and glimpsed works by Monet, Pissarro, Renoir, Degas, Gauguin, and many others, my imagination went to work. I heard Monet whisper to Renoir, "Why are thousands of people passing us by? What have they come to see?" Pissarro, a faithful friend of van Gogh, responded, "They have all come to see Vincent's paintings. I predicted that he would either go mad or surpass us all, and some say he did both!"

My first interest was to spend some time with the earliest oil painting in the collection, a stormy beach scene painted not far from The Hague in August of 1882, *Sheveningen Beach in Stormy Weather*.[47] I had reread Vincent's letter describing that day. He noted that the painting was

> made during a real storm, during which the sea came quite close to the dunes, was so covered with

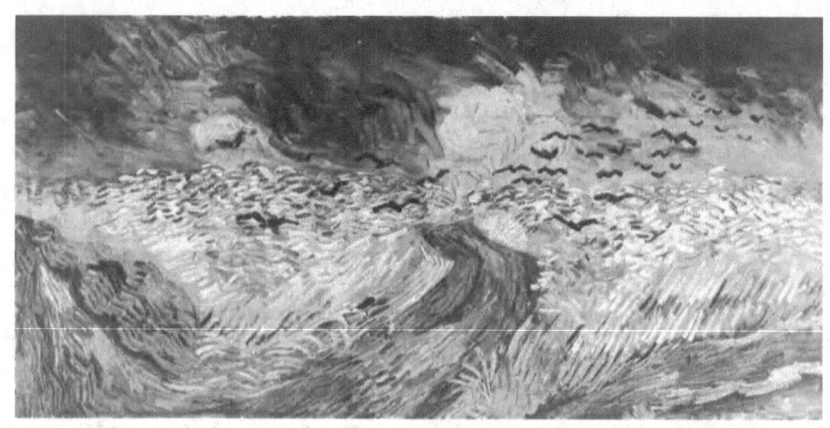

Wheatfield with Crows. Auvers-sur-Oise, July 1890. F779, JH2117, oil on canvas, 20⅛ x 39¾″. Vincent van Gogh Foundation, National Museum Vincent van Gogh, Amsterdam.

a thick layer of sand that I was obliged to scrape it off twice. The wind blew so hard that I could scarcely stay on my feet, and could hardly see for the sand that was flying around. (Letter 226)

On the surface of the painting, large, gritty pieces of sand stuck in the paint were visible, and smears that told of Vincent's struggle to hold the canvas in the wind and rain. His letter to Theo went on:

— a bit of sand, sea and sky — are serious subjects, so difficult, but at the same time so beautiful, that it is indeed worth while to devote one's life to expressing the poetry hidden in them. (Letter 226)

While viewing van Gogh's Paris paintings in the exhibit, I listened to two women engage in a friendly argument about which of them should have Vincent's little image called *Flowerpot with Chives*.[48] Each woman had a perfect place for it in her kitchen. Vincent loved to grow things, and his tiny kitchen garden in a clay pot must have given him a sense of nature even in an apartment in Paris. Such unassuming subjects scattered throughout the exhibit had a special attraction for visitors, who were touched by their simplicity.

The final painting in the exhibit was *Wheatfield with Crows*, the signature piece of the show.[49] Painted on the hill above Auvers in July 1890, the final month of Vincent's life, this work has attracted and disturbed the public and critics increasingly over the years. It has become the symbol of van Gogh's art and life.

Popular myth has it that *Wheatfield with Crows* was Vincent's last work, and was painted in the field where he would commit suicide by shooting himself with a borrowed revolver. The truth is that there are six or eight paintings done after *Wheatfield with Crows*, including a painting of harvested wheat, with sheaves standing in an open field. The association of *Wheatfield with Crows* with Vincent's suicide has cast an atmosphere of foreboding, fear, confusion, and violence over the work. That is unfortunate. I believe that painting is the image of Vincent's Gospel of Nature, a psalm of earth and sky, a harvest hymn that sings the interdependence of humans with other creatures, all under the overarching sky. It reveals the invisible power of the "something on high" that Vincent wrote of, the path of human labor, the germinating earth, and the cycle of the seasons that bring us again to harvest.

But most van Gogh experts do place the focus on the dark associations of the work. Meyer Shapiro's *Van Gogh*, for example, uses such terms as "disturbing violence," "pathetic disarray," "chaos," and "flickering void" to describe the painting. He tells us that "all things turned aggressively upon the beholder" and "the blue sky and yellow fields pull away from each other with disturbing violence."[50] H. R. Graetz, in *The Symbolic Language of Vincent van Gogh*, describes the "overripe" wheat as a "huge wildfire," the central path as "a dead end," and the crows as "sinister and foreboding," an "image of death."[51] Bernard Zurcher, in *Vincent van Gogh: Art, Life, and Letters*, sees in this painting van Gogh "disintegrating in the

heart of a maelstrom."⁵² Jan Hulsker, in *The New Complete Van Gogh*, calls the work "a doom-filled painting with threatening skies and the ill-omened crows."⁵³

But let us describe the painting for ourselves and suggest quite a different interpretation of its symbolic significance to Vincent, and quite another way to experience the work. A field of wheat ready for the harvest bends with the heavy grain and moves in harmony with the invisible winds from a deep, rich, stormy sky. Three paths of brown earth and green grass open directly before us and lead off the canvas to right and left. The central path curves into the golden wheatfield itself. Forty or more black crows are in flight over the wheat and in the sky. Empty paths invite us, wheat is alive with invisible power, and birds fly through it all in a symphony of wings.

Let us begin with Vincent's view of a stormy sky. His excitement at Sheveningen seems obvious as he remembered the crashing waves, flying sand, and a wind threatening to blow him off his feet. He speaks of the poetry hidden in such moments. Would a wheatfield under a stormy sky have made him feel less energized?

A baker who housed Vincent during his days as an evangelist in the mining villages of Belgium remembered:

> On a very hot day a violent thunderstorm burst over our region. What did our friend do? He went out to stand in the open field to look at the great marvels of God, and so he came back wet to the skin.⁵⁴

In The Hague, Vincent's love of storms remained constant. He tells of sheltering himself by a huge tree during a "violent thunderstorm with a terrific cloudburst" and reports:

> When it was over at last, and the crows flying again, I was not sorry I had waited, because of the beautiful deep tone which the rain had given to the soil.
>
> (Letter 227)

Zen Buddhist artists believed that anyone could find beauty in the graceful heron or stork, but only the enlightened could properly recognize the beauty of the crow.

He wrote Theo soon after:

> We are having very beautiful bad weather here at present, rain, wind, thunderstorms, but with splendid effects; that's what I like. (Letter 232)

After leaving The Hague for Drenthe and hiking some six hours across the lonely heath in rain and snow to a village called Hoogeveen, Vincent described for Theo how such a hike "on a stormy afternoon in rain and snow" both "calmed" and "cheered" him "greatly." He continued:

> I thought of you, brother, during that long walk across the heath, in the evening, in the storm.... I thought, those eyes of mine, here on this gloomy

> evening, wide awake in this deserted region — if they have been full of tears at times, why shouldn't these have been wrung from me by a sorrow that disenchants — yes — disturbs illusions — but at the same time — makes one wide *awake*. (Letter 344)

To all these positive characteristics, Vincent added another word of praise. He wrote Theo that "one grows in the storm" (Letter 544).

In a letter to Bernard, Vincent repeated words describing Delacroix, one of his favorite artists:

> I very much like the last words of, I think, Silvestre, who ended a masterly article this way: "Thus died — almost smiling — Delacroix, a painter of a noble race, who had the sun in his head and a thunderstorm in his heart, who turned from warriors to the saints, from the saints to the lovers, from the lovers to the tigers, and from the tigers to the flowers." (Letter B13)

A variation of the quotation might well describe Vincent: "The sun in his head, a thunderstorm in his heart, who painted miners and peasants, found saints among housewives and thistles, and turned finally to wheatfields, crows, and stormy skies."

Now let us test the view that the crows are a "sinister and foreboding" symbol. One of Vincent's sisters, Elisabeth, published a "personal recollection" of him in 1910, and in it she remembered him as a "young naturalist,"

with a special interest in studying birds in their natural habitat and collecting birds' nests.[55]

Certainly in Vincent's study of Japanese prints he saw many works that incorporated the crow as an artistic element. In his own collection of Japanese prints was a folding album featuring eight Kacho-ga, prints focusing on flowers and birds, including Hiroshige studies of the common black shrike.[56] Zen Buddhist artists believed that anyone could find beauty in the graceful heron or stork, but only the enlightened could properly recognize the beauty of the crow. For Vincent, the very ordinariness of the crow marked it as worthy of special notice. In one of Vincent's favorite books, Jules Michelet's *The Bird*, the crow is described in terms that spoke to Vincent:

> They interest themselves in everything, and observe everything. The ancients, who lived far more completely than ourselves in and with nature, found it no small profit to follow, in a hundred obscure things where human experience as yet affords no light, the directions of so prudent and sage a bird.[57]

But it is in the work of his hero, Millet, that Vincent saw great clouds of crows in dramatic natural settings. In *The Sower* a flight of crows descends from the sky. In *Reaper with Sickle* Vincent copied Millet's crows descending to the ripe wheat. Vincent's painting *The Plough and the Harrow*, a "translation" of Millet's *Winter: The Plain of Chailly*, faithfully renders the great spiral cloud of crows in the sky and many in the field and perched on the plough.[58] Sensier quotes from a letter Millet sent to the

artist Theodore Rousseau. Millet sets aside the "fine festivals at Notre Dame and the Hotel de Ville" described by Rousseau and says:

> I like... better the humbler ones given to me by the trees and boulders of the forest, the black flights of crows swooping down upon the plain.

He affirms his preference for "the solemnity of a man walking in the midst of a flight of crows."[59]

The paths and field of ripe wheat can be viewed similarly. While in Paris with his brother and family, before settling into Auvers, Vincent had seen a frieze-like painting by Puvis de Chavannes, *Between Art and Nature*. Vincent was moved by this painting to create thirteen or fourteen canvases of an unusual shape for his work in Auvers, canvases about forty inches by twenty inches. These canvases provided the wide panorama he employed for several paintings of wheatfields, including *Wheatfield with Crows*. The very breadth of the painting allows the paths to diverge in front of us, as though we must choose which path we will take. The emptiness of the paths encourages a sense of loneliness, and under the dark sky this solitude encourages a feeling of melancholy. This seems to be a part of what Vincent intended.

A letter from Theo on June 30, 1890, confessed to Vincent that he and Johanna had "gone through a period of the greatest anxiety," an illness that might have taken the life of baby Vincent. The child's "continuous plaintive crying all through many days and nights" had

led to sleeplessness and constant worry. To make it worse, Theo's employers had him "on short allowance," there was a worry over "money matters," and Theo was considering the sacrifices that would be necessary for all of them should he leave his job and strike out on his own (Letter T39). Vincent felt powerless. His advice was that mother and child would be far healthier living in the country rather than the city. His fear was "that being a burden to you, you felt me to be a thing to be dreaded" (Letter 649). After a visit to Theo and family, seeing their plight, Vincent returned to his work and hoped that what he was painting would bring a message of its own to them:

> There — once back here I set to work again — though the brush almost slipped from my fingers, but knowing exactly what I wanted, I have painted three more big canvases since.
>
> They are vast fields of wheat under troubled skies, and I did not need to go out of my way to express sadness and extreme loneliness. I hope you will see them soon — for I hope to bring them to you in Paris as soon as possible, since I almost think that these canvases will tell you what I cannot say in words, the health and restorative forces that I see in the country. (Letter 649)

The ripe grain, its color deepened by the stormy sky, promises wheat for bread and grain for the next planting. It has germinated in spite of all the difficulties of

the season, and even harvest time is not without its challenging yet purifying storms.

The empty paths have much to do with the mood of this painting. Vincent explored once more the sense of mystery that absence fosters. We noted earlier the "ghost" present in Vincent's painting of empty shoes, and the silent invitation to participate in the simplicity of the "nothing" in his bedroom painting. We add to these explorations his paintings of his and Gauguin's empty chairs in the Yellow House. Now we are invited to the sacramental journey of the missing peasants of Auvers, who wore seams into the earth with their coming and going to the wheatfields. The solitude of the artist at the meeting place of three paths calls us to recognize and celebrate the labor of ploughing, sowing, and harvest of the grain. The central groove of brown earth marks the tread of sabots over the years, the weight of a wheelbarrow rolled to the fields. The wider grooves of earth outside the strips of green grass mark the wheels of countless wagons carrying tools to the hill or harvests home from the field. Occasionally the wagons were draped in black and carried the body of one of the villagers up the hill and through the fields for planting in the small cemetery where Vincent and Theo now rest. A careful observer of the stand of wheat might detect the subtle opening among the wheat-stalks at the horizon where the winding central path into the wheat finally emerges.

Vincent sought to rediscover the lost gospel of earth and its creatures in harmony under the sun and in rain

and storm, a return to the garden where earth and human labor, winged creatures and sky meet. He sought to read for us the healing words recorded in what he called the "great book of nature." He drew upon the uniqueness of his and Theo's experience among the fields and peasant huts of their childhood in the Brabant region of southern Holland. When Vincent directed Theo's attention to what he called the "money-wolves" among the city merchants and financiers of their day, the institutions Zola labeled "Swine and Company," he went on to affirm that "we have our roots in a different kind of family."

> I hope there will always remain in us something of the Brabant fields and heath, which years of city life will not be able to wipe out, especially as it is renewed and strengthened by art. (Letter 247)

In a later letter he renewed the theme of the unique experience and sensitivity to nature shared with his brother, and the effect of this on his art:

> The real thing is not an absolute copy of nature, but to know nature so well that what one makes is fresh and true — that is what so many lack....
>
> You will say that everybody has seen landscapes and figures from childhood on. The question is, has everybody also been thoughtful as a child, has everybody who has seen them really loved the heath, fields, meadows, woods, and the snow and the rain and the storm? *Not* everybody has done this

the way you and I have: a peculiar kind of surroundings and circumstances must contribute to it, and a peculiar temperament and character must help it take root. (Letter 251)

So Vincent, encouraged by the example of Millet, went deeply into nature. He made virtues of necessities: lack of formal training, lack of funds for models, failure to interest art dealers, the disastrous attempt to create a studio of the South and an association of artists. All these factors drew him more completely into a solitude that listened to the voices of nature. As he described this calling:

> In a certain way I am glad I have not learned painting.... But I find in my work an echo of what struck me, after all I see that nature has told me something, has spoken to me, and that I have put it down in shorthand. In my shorthand there may be words that cannot be deciphered, there may be mistakes or gaps; but there is something of what wood or beach or figure has told me in it, and it is not the tame or conventional language derived from a studied manner or a system rather than from nature itself. (Letter 228)

Vincent, out of the sensitivities of his childhood and the necessities of his failures and solitude, learned to listen to nature. He had responded to Zola's view of a work of art as "a bit of creation, seen through a temperament." As he translated this earlier in a letter to Theo:

> I still can find no better definition of art than this "Art is man added to nature" — nature, reality, truth, but with a significance, a conception, a character, which the artist brings out in it, and to which he gives expression, which he disentangles, sets free and interprets. (Letter 130)

But putting nature's voice on canvas was no passive act:

> I want something more concise, more simple, more serious; I want more soul and more love and more heart. (Letter 252)

Viewing the art Vincent created during the last seventy days of his life in Auvers, we uncover a further theme that has remained hidden in his work and missed by over a century of van Gogh interpretation. Earth, germination, nurture, and women predominate in his work. Growing things and women are a symbolic center for the height of his art. They reflect his earlier images of cradle and cradle-rocker, as well as his love of books by women, including the works of Mary Ann Evans (George Eliot) and Harriet Beecher Stowe. They call to mind the importance of his exchange of letters with Wilhelmina, in which he expressed his admiration for her work nursing the sick and her care of their mother (Letters W11, W19).

There is a feminine sensitivity that more and more determined Vincent's view of soul, love, and heart as essential to his listening for the voice of nature and interpreting

its language in his art. Patient listening, meditative attentiveness, and nurturing awareness increasingly emerge in his work. Earth, germination, sowing time, the cradle, mother and child, and the harvest finally permeate his paintings and letters. A revealing passage in his letters names several favorite male artists and writers whose "beautiful serenity" expressed a rejuvenation of society:

> Sensitive, delicate, intelligent like women, also sensitive to their own suffering, and yet always full of life and consciousness of themselves, no indifferent stoicism, no contempt for life, I repeat — those fellows, they die as women die. No fixed idea about God, no abstractions, always on the firm ground of life itself, and only attached to that. I repeat, like *women* who have loved much, hurt by life, and as Silvestre says of Delacroix, "They die almost smiling." (Letter 451)

To believe in God is to feel that there is a God, not dead or stuffed but alive, urging us to love again with irresistible force.

Vincent shared in many of the confusions of his age regarding sexuality and gender, but the Western emphasis on male dominance, and escape from the female body and earth to male abstraction, reason, and mind, were not the direction Vincent sought in his art. He made clear that he wished painting a picture was like having

a child, but he was sure that childbirth and a mother's nurturing took precedence over art (Letter 641a).

Vincent's words, "no fixed idea about God... always on the firm ground of life itself," witness to the direction his own spirituality took. He had experienced the God of his father's system to be dead:

> To me, to believe in God is to feel that there is a God, not dead or stuffed but alive, urging us to love again with irresistible force — that is my opinion.
> (Letter 161)

Vincent preferred a humble recognition of the great mystery to a pride that claimed to know too much:

> I see that Millet believed more and more firmly in 'Something on High.'... He left it more vague, but for all that I see more in Millet's vagueness than in what Father says. (Letter 337)

Vincent sought to relate the mystery of love and the mystery of God:

> But I love, and how could I feel love if I did not live and others did not live; and then if we live, there is something mysterious in that. Now call it God or human nature or whatever you like, but there is something which I cannot define systematically though it is very much alive and real, and see that is God, or as good as God. (Letter 164)

A Harvest Hymn

"God" is the name we might use for the mystery of love's presence in life. "God" and "love" are not the possession of religions, which pass away, or even of art and literature. Love resides in the simplicity of life itself, in the germinating power of the family and the wheatfield:

> What a mystery life is, and love is a mystery within a mystery. It certainly never remains the same in a literal sense, but the changes are like the ebb and flow of the tide which leaves the sea unchanged.
>
> (Letter 265)

Vincent's uneasiness with the term "God" and his searching for something we have in common with all life put him in the "creation spirituality" Matthew Fox locates in the mysticism of Meister Eckhart. In sermons preached near the year 1300 Eckhart said:

> Therefore pray God to rid us of "God" so that we may grasp and eternally enjoy the truth where the highest angel and the fly and the soul are equal.[60]

The more noble something is, the commoner it is. I have my senses in common with the animals, and my life in common with the trees. My being, which is more inward, is held in common with all creatures. Heaven is more encompassing than all that is under it, and for this reason is more noble. Love is noble because it is all-encompassing.[61]

The central portion of *Wheatfield with Crows* is the wheat itself, the clear focus of his last paintings. A year

earlier, in July 1889, Vincent had written to Wilhelmina from the asylum at Saint-Rémy:

> I, who have neither wife nor child, feel the need of seeing the wheatfields, and it would be difficult for me to stay in a city for any length of time.
>
> (Letter W13)

The same letter develops the life of wheat into a metaphor for human life.

> What else can one do, when we think of all the things we do not know the reason for, than go look at a field of wheat? The history of those plants is like our own; for aren't we, who live on bread, to a considerable extent like wheat, at least aren't we forced to submit to growing like a plant without the power to move, by which I mean in whatever way our imagination impels us, and to being reaped when we are ripe, like the same wheat? (Letter W13)

The very focus of Vincent's trip to Provence was to find a French equivalent of Japan where he might learn to see nature as the Japanese artists did (Letters 469, 500). During his first summer in Arles, Vincent described what he wanted to learn from the Japanese artist:

> If we study Japanese art, we see a man who is undoubtedly wise, philosophic and intelligent, who spends his time doing what? In studying the distance between the earth and the moon? No. In

studying Bismarck's policy? No. He studies a single blade of grass.

But this blade of grass leads him to draw every plant and then the seasons....

Come now, isn't it almost a true religion which these simple Japanese teach us, who live in nature as though they themselves were flowers? (Letter 542)

Buddhist philosophers focus on the decentering of the human ego and recognition of our shared transiency with all things in the universe as the key to salvation. As Dr. Masao Abe, a Zen Buddhist scholar, wrote:

Buddhist salvation is thus nothing other than awakening to reality through the death of the ego, i.e., the existential realization of the transiency common to all things in the universe, seeing the universe really *as it is*.[62]

This was not a new way of thinking for Vincent, but a confirmation of his feelings for nature since childhood. Nor was it a Buddhist alternative to Jesus, but a parallel to the artistry of Christ, whose parables, according to Vincent, present the same great themes of nature: "What a sower, what a harvest, what a fig tree!" (Letter B8).

To study nature by painting it, to identify with nature through the cycle of the seasons, was for Vincent a meditative way into the gospel of the nurturing earth, a creation theology.

While in the asylum at Saint-Rémy, Vincent had again made a virtue of necessity. He could see one small

wheatfield out his window, and he painted it over and over again, from plowing to sowing, from green sprouts to golden wheat, in sunshine and in rain. He painted a favorite work of his during this period, a reaper with a hand sickle cutting the wheat in that field outside his barred window. His identification of wheat and humans with universal transiency had become an awakening for him. He described the painting for Theo:

> For I see in this reaper — a vague figure fighting like a devil in the midst of the heat to get to the end of his task — I see in him the image of death, in the sense that humanity might be the wheat he is reaping. So it is — if you like — the opposite of that sower I tried to do before. But there is nothing sad in this death, it goes its way in broad daylight with a sun flooding everything with a light of pure gold. (Letter 604)

When all nature joins us in the changing of the seasons, we are not alone in death, but rather are part of the great miracle of seasonal transformation:

> I feel so strongly that it is the same with people as it is with wheat, if you are not sown in the earth to germinate there, what does it matter? — in the end you are ground between the millstones to become bread.
> The difference between happiness and unhappiness! Both are necessary and useful, as well as death or disappearance. (Letter 607)

Vincent's last letter to his brother urges him to move his family to the countryside for health and restoration. He fears further attacks coming that will require expensive hospitalization for himself. His suicide was a sacrifice so that his brother's resources would be used for the baby. He lived out his interpretation of the "Suffering Servant" passage in his father's Bible. Unfortunately, in doing what he thought was "necessary and useful," Vincent did not realize that he was as important to Theo as Theo had been to him. Brokenhearted, and likely suffering from tuberculosis, Theo died within months of Vincent.

Wheat and artist become in death the seed for the next sowing. In the cemetery among the wheatfields on that hill in Auvers, it is not unusual to find that someone, perhaps a nearby farmer or a pilgrim, has placed a few stalks of wheat on Vincent's grave.

THIRTEEN

The Eye with Which God Sees Me

Vincent van Gogh died in the summer of 1890 at age thirty-seven. He had worked at his drawing and painting for just ten years. Theo, Vincent's sole support, died six months later, at age thirty-three. Theo had been married just a year and a half and left a young wife and a small child. His wife was left with a collection of hundreds of paintings and drawings by her brother-in-law Vincent, work most viewed as of little value. In a diary entry for November 15, 1891, about ten months after her husband's death, Johanna wrote:

> Beside the care for the child he left me yet another task, Vincent's work — to show it and to let it be appreciated as much as possible. All the treasures that Theo and Vincent collected — to preserve them inviolate for the child — that also is my task. I am not without an object in life, but I feel lonely and deserted.[63]

In a letter to a friend, Johanna wrote of another treasure left to her. In Theo's desk she discovered bundles of letters from brother Vincent:

The letters have taken a large place in my life already, since the beginning of Theo's illness. The first lonely evening which I spent in our home after my return I took the package of letters. I knew that in them I should find him again. Evening after evening that was my consolation after the miserable days. It was not Vincent whom I was seeking but Theo. I drank in every word, I absorbed every detail. I not only read the letters with my heart, but with my whole soul. And so it has remained all the time. I have read them, and reread them, until I saw the figure of Vincent clearly before me. Imagine for one moment my experience, when I came back to Holland — realizing the greatness and the nobility of that lonely artist's life. Imagine my disappointment at the indifference which people showed, when it concerned Vincent and his work.... I remember how last year, on the day of Vincent's death, I went out late in the evening. The wind blew, it rained, and it was pitch dark. Everywhere in the houses I saw light and people gathered around the table. And I felt so forlorn that for the first time I understood what Vincent must have felt in those times when everybody turned away from him, when he felt "as if there were no place for him on earth...." I wished that I could make you feel the influence Vincent had on my life. It was he who helped me accommodate my life in such a way that I can be at peace with myself. Serenity — this was the favorite word of both of them, the something they

considered the highest. Serenity — I have found it. Since that winter, when I was alone, I have not been unhappy — "sorrowful yet always rejoicing," that was one of his expressions, which I have come to understand now.[64]

Young Vincent became an engineer. In the memoir of Johanna's life, he documented his mother's efforts through the 1890s and early years of the twentieth century to arrange showings of Vincent's work, convinced that he would one day be vindicated, and that Theo would "rejoice in the recognition of his brother." Johanna's efforts were often met with indifference, and Vincent's work continued to have many detractors. In 1905, in order to exhibit Vincent's work in the Stedelijk (municipal) Museum of Amsterdam, Johanna had to hire the galleries. In 1910, when Vincent's paintings were shown for the first time in London, "many people still laughed at them." The dedicated community that began with two, Vincent and Theo, became a community of four. But Johanna and her son had no easy road in bringing the pictures before the public eye, first in Holland and Belgium, then in Germany and France, and finally in the world. The artist's dream of an association dedicated to art for all failed in the form he imagined, but succeeded nevertheless through his dedicated family group.

In the fall of 1907, the artist Mathilde Vollmoeller carried a portfolio of forty reproductions of Vincent van Gogh's paintings to Paris. There she showed them to

the German poet Rainer Maria Rilke. He was astonished by what he described as these "tireless, touching works" by an artist in whom "something of the spirit of Saint Francis was coming back to life." Rilke was married to Clara Westhoff, a pupil of Rodin, had written essays on Rodin and Cézanne, and had made two trips to Russia to study the art of the icon. Writing from Paris to his wife in Germany, Rilke provided a brief, poetic biography of van Gogh, a sort of poem on Vincent's life work:

> An art dealer, and since he somehow realizes after three years that that wasn't it, a little school-teacher in England. And in the midst of that the decision: to become a priest. He goes to Brussels to learn Greek and Latin. But why the detour? Aren't there people somewhere who don't expect their priest to know Greek or Latin? And so he becomes what is called an evangelist, and he goes to a mining district and tells people the story of the gospel. And while he talks, be begins to draw. And finally he doesn't even notice how he's stopped talking and is only drawing. And from then on, that's all he does, until his last hour, when he decides to stop everything because he might not be able to paint for weeks; at that point it seems natural to him to give up everything, especially life. What a biography.[65]

Rilke, himself a God-seeker, mystic, and nomad, went on to provide his wife with an interpretation of the essence of van Gogh's life and work:

He holds out his face and you take note of the fact: he's in a bad way, day and night. But in his paintings (the *blossoming tree*) poverty has already become rich: a great splendor from within. And that's how he sees everything: as a poor man; just compare his *parks*. These too are expressed with such quietness and simplicity, as if for poor people, so they can understand; without going into the extravagance that's in these trees; as if to do that would already be taking sides. He isn't on anyone's side, isn't on the side of the parks, and his love for all these things is directed at the nameless, and that's why he himself concealed it. He does not show it, he has it. And quickly takes it out of himself and puts it into the work, into the innermost and incessant part of the work: quickly: and no one has seen it.[66]

Finally Rilke attempted to draw from van Gogh's work a lesson for his own life and poetry, which were not going very well at that time. Again he wrote to Clara:

Van Gogh could perhaps lose his composure, but behind it there was always his work, he could not lose that.... Perhaps one has to have a clearer insight into the nature of one's "task," get a more tangible hold on it, recognize it in a hundred details. I believe I do feel what van Gogh must have felt at a certain juncture, and it is a strong and great feeling: that everything is yet to be done: everything. But this devotion to what is nearest, this is something I can't do as yet, or only in my best moments,

while it is at one's worst moments that one really needs it. Van Gogh could paint an Interior of the Hospital, and in his most anxious days he painted the most disquieting object. How else could he have survived.[67]

Rilke found in Vincent's life and work a promising path through his own weakness and distractions. All of us are astonished by Vincent's ability to begin again after each failure or detour, his childlike ability to begin each painting with a fresh sense of excitement and expectation.

Three images come to my mind as I close this work. One is the little village cemetery on the hill overlooking Auvers. Villagers are still laid to rest in that cemetery, where photographs of the deceased and pots of flowers are placed, making many of the gravesites colorful and ornate. But the small, gray gravestones of Vincent and Theo, which rest against one wall, are among the simplest in the cemetery. Outside that wall are the same fields of wheat and farmers' paths Vincent once painted. Vincent had written that "humility becomes me." The stones simply read: "Here Rests Vincent van Gogh 1853–1890" and "Here rests Theodore van Gogh 1857–1891." There is no reference to the art they gave the world. Ivy planted years ago on the graves has bound the two brothers together in death as they were in life.

The second image is a statue honoring Vincent and Theo that stands near the Dutch Reformed Church of Zundert, the village where the two brothers were born,

and where their father, Theodorus, was once pastor. The two brothers seem to merge in the statue, their heads touching, arms holding one another. There is an opening in the sculpture at the center of their bodies through which one can see the sky, the trees, and their father's church. At the base are words taken from the draft of a letter Theo found in Vincent's pocket after his death:

> Through my mediation you have your part in the actual making of certain canvases which even in the catastrophe keep their calm. (Letter 652)

All of us are astonished by Vincent's ability to begin again after each failure or detour, his childlike ability to begin each painting with a fresh sense of excitement and expectation.

The third image is a memory-collage of the many museums where I have watched the watchers respond to Vincent's paintings. Parents hold their children up to see an orchard, youngsters stare up at fishing boats or a cypress tree, families whisper excitedly in front of a sunflower or Vincent's bedroom. There is a sense that they know Vincent and can call him by his first name, and an equal sense of wonder that they are face to face with one of his luminous works.

In his work *Painting the Word: Christian Pictures and Their Meanings*, John Drury, New Testament interpreter and scholar of religion and art, wrote:

Painters, if they are to be "God's spies," have to go a good way further than theologians down the ethical road of incarnation, with the silent renunciations, the obedient humility and love for the world of mortal appearances which it demands, if they are to make the mystery of things visible.[68]

Vincent van Gogh has achieved this.

Chronology of Nine Van Gogh Works

Drawing and Paintings Discussed in Chapters 4 through 12

1853	March 30. Birth of Vincent van Gogh, Zundert, The Netherlands
1. 1883	March. The Hague, The Netherlands *Child in Cradle with Kneeling Girl* See chapter 4
2. 1885	Autumn. Neunen, The Netherlands *Still Life with Open Bible and Zola Novel* See chapter 5
3. 1886	July–September. Paris *Pair of Old Shoes* See chapter 6
4. 1888	April. Arles, Provence, France *Pear Tree in Bloom with Butterfly* See chapter 7
5. 1888	October. Arles, Provence *Vincent's Bedroom* See chapter 8
6. 1888	December 1988–March 1989 Arles, Provence *La Berceuse* Five versions painted. See chapter 9

Chronology of Nine Van Gogh Works

7. 1889 June. Saint-Rémy, Provence
 Starry Night
 See chapter 10

8. 1890 January. Saint-Rémy, Provence
 First Steps
 See chapter 11

9. 1890 July. Auvers-sur-Oise, France
 Wheatfield with Crows
 See chapter 12

 1890 July 29. Death of Vincent van Gogh,
 Auvers-sur-Oise, France

Appendix

Illustrations

Nine artworks by Vincent van Gogh are at the heart of this book, each as the focus of a chapter, from chapter 4 through chapter 12. This art spans the years and sites of Vincent's life as an artist. The first work featured was done in chalk and pencil (*Child in Cradle with Kneeling Girl*), while the other eight works are oil paintings. Because we are printing these works in black-and-white, we have chosen Vincent's own black-and-white sketches and drawings related to the oil paintings whenever such are available. Where we have no sketch or drawing by the artist, we have printed a black-and-white photo of the oil painting. In one case we have printed the photo of a work by Millet over which Vincent drew a grid to aid him in copying the work (*First Steps*, by Jean-François Millet).

Many wonderful collections of color prints of Vincent van Gogh's art are available, often quite reasonably. We direct you to those volumes to view his works in large format and in color. Having such color prints beside you as you read may enrich the experience as we seek the layers of meaning in the artist's life and art. Two catalogues attempting to bring together all of the artist's work have assigned numbers to his paintings, and those numbers are used in most books on van Gogh to guide you to the paintings being discussed. Jacob-Baart de la Faille's *The Works of Vincent van Gogh*, published in 1928 and revised in 1970, assigned numbers that are designated with the letter F. More recently, the great Dutch scholar Jan Hulsker added to the number of works considered in his *The Complete Van Gogh* (1980) and *The New Complete Van Gogh* (1996). His numbering of Vincent's paintings, drawings, and sketches is designated by the letters JH. So, for example, Vincent's *Pair of Old Shoes* of 1886 is F255 and JH1124.

Most of the photos in this collection of illustrations come to us thanks to the Vincent van Gogh Foundation, The National Museum Vincent van Gogh, Amsterdam. The pen drawing of *Starry Night* is an exception. It is variously listed as "lost, formerly at the Kunsthalle Bremen," as "destroyed in World War Two," or, in *The New Complete Van Gogh* of Jan Hulsker, as in the Museum of Architecture, Moscow. The photo of Vincent's painting

Illustrations

First Steps (after Millet) comes to us thanks to the Metropolitan Museum of Art in New York. Titles to the paintings, drawings, and sketches may give some confusion. We simply employed a descriptive title, as Vincent did not normally title his works.

As the single-volume edition of Ingo Walther and Rainer Metzger's *Vincent van Gogh: The Complete Paintings* (Cologne: Taschen, 2002) is available in many bookstores, and as Jan Hulsker's *The Complete Van Gogh* (New York: Harry N. Abrams, 1980) is available in many libraries, I will note here where they have color prints of the works discussed in this book. Further, to guide you to the works themselves, I will note the museums or collections that contain the originals.

1. *Child in Cradle with Kneeling Girl* (see chapter 4, page 29) is in black chalk and pencil, and can be found at the National Museum Vincent van Gogh in Amsterdam (F1024, JH336).

2. *Still Life with Open Bible and Zola Novel* (chapter 5, page 38) appears in color on page 104 in Walther and Metzger, and on page 187 in Hulsker. The painting is in the National Museum Vincent van Gogh in Amsterdam (F117, JH946).

3. *Pair of Old Shoes*, painted in 1886 (chapter 6, page 50), is in color in Walther and Metzger, 183, and in *The New Complete Van Gogh* of Jan Hulsker, 246. The painting is in the National Museum Vincent van Gogh in Amsterdam (F255, JH1124).

4. *Pear Tree in Bloom with Butterfly* (chapter 7, page 59) is printed in color in Walther and Metzger, 322, and the painting is in the National Museum van Gogh in Amsterdam (F405, JH1394).

5. *Vincent's Bedroom* (chapter 8, page 68) is printed in color in Walther and Metzger, 442, with two further versions of the painting at 548 and 549. The original painting is in the National Museum Vincent van Gogh in Amsterdam with two other versions by the artist in the Art Institute of Chicago and the Musée d'Orsay in Paris (F482, JH1608; also F483, JH1793 and F484, JH1771).

6. *La Berceuse* (chapter 9, page 82) is printed in color, along with four other versions by the artist, on pages 481–83 in Walther and Metzger. The five La Berceuse paintings are in the Annenberg Collection on loan to the Metropolitan Museum of Art in New York, the Art Institute of Chicago, the Boston Museum of Fine Arts, the National Museum Kröller-Müller in Otterlo outside Amsterdam, and in the National Museum Vincent van Gogh in Amsterdam (F505, JH1669; also F506, JH1670; F508, JH1671; F504, JH1655; F507, JH1672).

7. *Starry Night* (chapter 10, page 91) is printed in color in Walther and Metzger, 520–21, and Hulsker, 401. The painting hangs in the Museum of Modern Art in New York (F612, JH1731).

8. *First Steps* (chapter 11, page 103) is printed in color in Walther and Metzger, 609. The painting is at the Metropolitan Museum of Art in New York (F668, JH1883).

9. *Wheatfield with Crows* (chapter 12, page 114) is in color in Walther and Metzger, 690–91, and the painting is in the National Museum Vincent van Gogh in Amsterdam (F779, JH2117).

Notes

Preface

1. "Life with Picasso" by Françoise Gilot and Carlton Lake, in *Van Gogh: A Retrospective,* ed. Susan Stein (New York: Macmillan, 1986), 379.

2. For a careful analysis of the many ways the relationship of religion to art has been conceived over the ages, both East and West, see Earle Coleman, *Creativity and Spirituality: Bonds between Art and Religion* (Albany: State University of New York Press, 1998).

3. For example, there is the excellent work by Jan Hulsker, *The New Complete Van Gogh: Paintings, Drawings, Sketches* (Amsterdam: J. M. Meulenhoff, 1996), and the work by Ingo Walther and Rainer Metzger, *Van Gogh: The Complete Paintings* (Cologne: Taschen, 2002).

One: The Eye with Which I See God

4. Paul Tillich, *Dynamics of Faith* (New York: Harper & Row, 1957), 42.

5. Ibid., 42–43.

6. See Brother David Steindl-Rast's foreword in David O'Neal, *Meister Eckhart: From Whom God Hid Nothing* (Boston: Shambhala, 1996), xi. For an excellent overview of Eckhart, especially his perspective on God and nature, see Matthew Fox, *Breakthrough: Meister Eckhart's Creation Spirituality in New Translation* (Garden City, N.Y.: Doubleday, 1980).

7. For an overview of Henri Nouwen's life and writings, see Jurjen Beumer, *Henri Nouwen: A Restless Seeking for God,* trans. D. Schlaner and N. Forest-Flier (New York: Crossroad, 1999), and Deirdre LaNoue, *The Spiritual Legacy of Henri Nouwen* (New York: Continuum, 2000). Also of help is *Seeds of Hope: A Henri Nouwen Reader,* ed. Robert Durback (New York: Image Books, 1997).

Two: Henri Nouwen and the Abbey

8. For the influence of Japanese art on the Impressionists, see Siegfried Wichmann's *Japonisme: The Japanese Influence on Western Art in the 19th*

and 20th Centuries (New York: Park Lane, 1985), and Gabriel Weisberg et al., *Japonisme: Japanese Influence on French Art 1854–1910* (Cleveland: Cleveland Museum of Art, 1975).

9. See Tsukasa Kodera, *Catalogue of the Van Gogh Museum's Collection of Japanese Prints*, including the "Introduction on Van Gogh's Utopian Japonisme" (Zwolle, Holland: Waanders, 1991), 11–45, and Willem van Gulik's "An Introduction to the Japanese Prints in the Collection of the Van Gogh Museum," 47–53.

10. See Henri Nouwen's *The Road to Daybreak: A Spiritual Journey* (Garden City, N.Y.: Doubleday, 1988).

11. See the annotated bibliography in *Seeds of Hope: A Henri Nouwen Reader* (New York: Image Books, 1997), 271–86.

12. See the foreword by Sue Mosteller and the afterword by Nathan Ball in Henri Nouwen, *Sabbatical Journey: The Diary of His Final Year* (New York: Crossroad, 1998), vii–xi, 223–26.

Three: Vincent's Conversion to Painting

13. Meyer Shapiro, *Van Gogh* (Garden City, N.Y.: Doubleday, 1980), 11–12.

14. This exhibit is described in Richard Kendall, *Van Gogh's Van Goghs: Masterpieces from the Van Gogh Museum, Amsterdam*, with contributions by John Leighton and Sjaar van Heugten (Washington, D.C.: Harry V. Abrams, 1998). A similar visit of sixty paintings and sixty drawings by van Gogh traveled to the Guggenheim in New York and the Washington Gallery of Modern Art in 1964, just before they were to be placed for the first time in the Van Gogh Museum of Amsterdam, which was then being built. See the catalogue, *Vincent van Gogh: Paintings, Watercolors and Drawings*, with an opening essay by V. W. van Gogh, the artist's godchild (Amsterdam: J. M. Meulenhoff, 1996).

Four: The Birth of God

15. On Clasina Maria Hoornik and Vincent, see, for example, Marc Edo Tralbaut, *Van Gogh* (Lausanne: Chartwell Books, 1969), 89–110. Johanna van Gogh-Bonger, Theo's widow, took a very negative view of "Sien" in the "Memoir of Vincent van Gogh" in volume 1 of *The Complete Letters of Vincent Van Gogh*, introduction by V. W. van Gogh; preface and memoir by J. van Gogh-Bonger (Boston: New York Graphic Society, 1981). See p. xxxiii, where she describes her as "a coarse, uneducated woman, marked by smallpox, who spoke with a vulgar accent and had a spiteful character, who was addicted to liquor and smoked cigars,... who drew him into all kinds of intrigues with her family."

16. See the very revealing collection of letters to Bernard in *The Complete Letters of Vincent Van Gogh*, 3:473–527. On Bernard's life and work, see *Emile Bernard 1861–1941: A Pioneer of Modern Art*, ed. Mary Anne Stevens (Zwolle, Holland: Waanders, n.d.).

Five: The Mystery of His Father's Bible

17. "ISAIE LIII" can be clearly seen in color plate xi, Jan Hulsker, *The New Complete Van Gogh: Paintings, Drawings, Sketches* (Amsterdam: J. M. Meulenhoff, 1996), 187. Though the Bible was in Dutch, Vincent was sending the painting to Theo in Paris, and so used the French for "Isaiah."

18. The French text can be found in *Les Rougon-Macquart: Histoire naturelle et social d'une famille sous le Second Empire*, 5 vols., ed. Henri Mitterand (Dijon: Bibliothèque de la Pleiade, 1965), 3:833.

19. On Vincent's reading of the literature of his day, see Judy Sund, *True to Temperament: Van Gogh and French Naturalist Literature* (New York: Cambridge University Press, 1992).

20. From the worn corners of the pages of the Bible at the Isaiah passage, it is possible that the same "Suffering Servant" text was a favorite of his father. This would be all the more poignant, as Pastor van Gogh, from Vincent's perspective, missed the true import of the passage, Vincent's attempt to live that mission, and its restatement in modern dress in the Zola novel.

Six: Empty Shoes

21. Bogomila Welsh-Ovcharov, *Van Gogh in Perspective* (Englewood Cliffs, N.J.: Prentice-Hall, 1974), 33–34.

22. Martin Heidegger, "The Origin of the Work of Art," in *Basic Writings from Being and Time to The Task of Thinking*, ed. David Krell (New York: Harper & Row, 1977), 159.

23. Chang Chung-yuan, *Creativity and Taoism: A Study in Chinese Philosophy, Art, and Poetry* (New York: Harper Torchbooks, 1970), plate 4 and accompanying comments.

24. Yasuichi Awakawa, *Zen Painting*, trans. John Bester (Tokyo: Kodansha International, 1970), 54.

25. Thomas Carlyle, *Sartor Resartus* (London: Chapman and Hall, 1897).

26. *A Christmas Carol*, in *Christmas Books of Charles Dickens* (New York: Black's Readers Service Company, n.d.), 93.

27. Quoted from Whitman's "A Backward Glance" in Jessica Haigney, *Walt Whitman and the French Impressionists: A Study in Analogies*, Studies in American Literature 10 (Lewiston, N.Y.: Edwin Mellon Press, 1990), 78.

Seven: Blossoming Trees and Butterflies

28. On Samuel Bing, see Siegfried Wichmann's *Japonisme: The Japanese Influence on Western Art in the 19th and 20th Centuries* (New York: Park Lane, 1985), 8–12. The prints owned by Vincent and Theo can be seen in Tsukasa Kodera, *Catalogue of the Van Gogh Museum's Collection of Japanese Prints*, including the "Introduction on Van Gogh's Utopian Japonisme" (Zwolle, Holland: Waanders, 1991).

29. For a day-by-day description of van Gogh's life and work during this period, see Ronald Pickvance, *Van Gogh in Arles* (New York: Metropolitan Museum of Art, 1984).

30. *The Poems of Emily Dickinson*, ed. R. W. Franklin (Cambridge, Mass.: The Belknap Press of Harvard University Press, 1999), poem 1107, pp. 447–48.

Eight: Vincent's Bedroom

31. Ronald Pickvance in *Van Gogh in Arles* (New York: Metropolitan Museum of Art, 1984) details all van Gogh's work there.

32. *The Poems of Emily Dickinson*, poem 1611, pp. 589–90.

33. On the confusing complexity of theories regarding Vincent's illness, see the careful analysis by Wilfred Arnold in *Vincent van Gogh: Chemicals, Crises, and Creativity* (Boston: Birkhauser, 1992). Arnold favors the theory that van Gogh and several family members suffered from acute intermittent porphyria, a metabolic disorder.

Nine: La Berceuse

34. Pierre Loti's *An Iceland Fisherman* (New York: P. F. Collier and Son, 1902), 4. Loti was actually the French naval officer Louis Marie Julien Viaud. Vincent was particularly fond of Viaud's book *Madame Chrysantheme* (Chicago: Donohue and Henneberry & Co., 1892), set in Japan.

Ten: Starry Sky

35. Marc Edo Tralbaut, *Van Gogh* (Lausanne: Chartwell Books, 1969), provides photos of the asylum and its grounds, as well as asylum documents related to van Gogh, 273–91.

36. Ronald Pickvance, *Van Gogh in Saint-Rémy and Auvers* (New York: Metropolitan Museum of Art, 1986), 103.

37. A. Sensier and P. Mantz, *Jean-François Millet, Peasant and Painter*, trans. H. de Kay (Cambridge, Mass.: J. R. Osgood, 1881), 120.

38. Ibid., 120–23.

39. Griselda Pollock, *Millet* (London: Oresko Books, 1977), 44.

40. Walt Whitman, *Leaves of Grass* (New York: Barnes and Noble, 1993), "Prayer of Columbus," 351–53.
41. "When I Heard the Learn'd Astronomer," ibid., 228.

Eleven: First Steps

42. For the image of Millet's crayon on paper of *First Steps*, Vincent's oil painting, and the photo of Millet's work on which Vincent had drawn a grid for copying, see Louis van Tilborgh, "Van Gogh's Copies after Millet," in *Van Gogh and Millet*, ed. Louis van Tilborgh (Zwolle, Holland: Waanders, 1989), 111–14.
43. A. Sensier and P. Mantz, *Jean-François Millet, Peasant and Painter*, trans. H. de Kay (Cambridge, Mass.: J. R. Osgood, 1881), 127.
44. Ibid., 120–23.
45. Ibid., 157.

Twelve: Wheatfield with Crows

46. See the catalogue of the exhibit, *Van Gogh's Van Goghs: Masterpieces from the Van Gogh Museum, Amsterdam*, with contributions by John Leighton and Sjaar van Heugten (Washington, D.C.: Harry V. Abrams, 1998).
47. Ibid., 21.
48. Ibid., 65.
49. Ibid., 140–41.
50. Meyer Shapiro, *Van Gogh* (Garden City, N.Y.: Doubleday, 1980), 130.
51. H. R. Graetz, *The Symbolic Language of Vincent van Gogh* (New York: McGraw-Hill, 1963), 278.
52. Bernard Zurcher, *Vincent van Gogh: Art, Life, and Letters* (New York: Rizolli, 1985), 277, 283–84.
53. Jan Hulsker, *The New Complete Van Gogh: Paintings, Drawings, Sketches* (Amsterdam: J. M. Meulenhoff, 1996), 278.
54. In a letter to "Monsieur Pierard," in *The Complete Letters of Vincent Van Gogh*, introduction by V. W. van Gogh; preface and memoir by J. van Gogh-Bonger (Boston: New York Graphic Society, 1981), 1:226.
55. Elisabeth du Quesne, *Personal Recollections of Vincent van Gogh*, trans. K. Drier (New York: Houghton-Mifflin, 1913), 4.
56. Tsukasa Kodera, *Catalogue of the Van Gogh Museum's Collection of Japanese Prints*, including the "Introduction on Van Gogh's Utopian Japonisme" (Zwolle, Holland: Waanders, 1991), prints 57, 53a, 22, 348.
57. Jules Michelet, *The Bird* (London: Wildwood House, 1981), 16.
58. See the plates in Louis van Tilborgh, ed., *Van Gogh and Millet* (Zwolle, Holland: Waanders, 1989), 161, 130, 116–17.

59. A. Sensier and P. Mantz, *Jean-François Millet, Peasant and Painter*, trans. H. de Kay (Cambridge, Mass.: J. R. Osgood, 1881), 111.

60. Matthew Fox, introduction and commentaries, *Breakthrough: Meister Eckhart's Creation Spirituality in New Translation* (Garden City, N.Y.: Doubleday, 1980), 215 (sermon 15).

61. Ibid., 399 (sermon 29).

62. Masao Abe, "Man and Nature in Christianity and Buddhism," in *The Buddha Eye: An Anthology of the Kyoto School*, ed. Frederick Franck (New York: Crossroad, 1991), 153–54.

Thirteen: The Eye with Which God Sees Me

63. "Memoir of J. van Gogh-Bonger" in *The Complete Letters of Vincent Van Gogh*, introduction by V. W. van Gogh; preface and memoir by J. van Gogh-Bonger (Boston: New York Graphic Society, 1981), 1:lx–lxi.

64. Ibid., 1:lxv–lxvi.

65. Rainer Maria Rilke, *Letters on Cézanne*, ed. Clara Rilke, trans. Joel Agee (New York: Fromm International Publishing, 1985), 20.

66. Ibid., 20–21.

67. Ibid., 22–23.

68. John Drury, *Painting the Word: Christian Pictures and Their Meanings* (New Haven, Conn.: Yale University Press, 1999), 181.

Index

Abbey of the Genesee, 10, 12, 13
Abbot, 11, 14, 75
Abe, Masao, 131
Absence, 54, 56, 123
Abstract Expressionism, 100
Adoration of the Magi (Bernard), 36, 47
Adversity, 20, 79
Alcohol, 60
Alpilles (mountains), 92
Amsterdam, 7, 51, 52
Angelus, The (Millet), 109
Annenberg Collection, 81
Art, 3, 23, 52, 126
 Chinese, 53
 Japanese, 8, 61, 72, 130
Art Institute of Chicago, xi
Art Nouveau, 8, 6
Artists, 48, 78, 88, 110
Association of Artists, 74, 125
Asylum, 2, 5, 77, 90, 131
Autumn, 62
Awakawa, Yasuichi, 53

Baby, 28, 31
Balzac, Honoré de, 42
Barbizon, 109
Beat Generation, 12
Beauty, 47, 60, 96, 108, 115, 118
Bedroom, 3, 67, 77, 80, 108
Belgium, 9, 19
Berceuse, La (Van Gogh), 81–89
Bernard, Emile, 15, 34, 36, 47, 94
Between Art and Nature (Chavannes), 121
Bible, 6, 8, 37, 40, 46, 78
 Genesis, 93
 Psalm 119, 24

Bible (*continued*)
 Isaiah, 40, 44, 77
 Suffering Servant Songs, 40, 76, 133
 Parable of the Prodigal Son, 44
 1 Corinthians, 55
 Revelation, 93
Bing, Samuel (or Siegfried), 8, 61
Bird, The (Michelet), 120
Birds, 20–21, 120
Birth, 30, 35, 36
Birthday, 71, 76
Birthplace, 25
Blossoms, 60–65
Boch, Eugene, 67, 70, 93
Books, 6, 20, 35, 41, 77
Borinage, The, 19
Brabant, 124
Breton, 30, 78
Brittany, 74
Buddhism, 7, 12, 53, 75, 131
Burning Bush, 4
Butterfly, 59, 65–66, 98

Cage, 21
Cage, John, 12
Canvas, 26
Carlyle, Thomas, 55, 93
Caterpillar, 65, 98
Cathedral, 64
Cell, 2, 78, 92
Cemetery, 56, 123, 133, 139
Cézanne, Paul, 137
Church, 18, 20, 28, 83
Chang, Chung-yuan, 53
Chavannes, Puvis de, 105
Child, children, 28, 35, 56, 105, 112
Christ, 35, 48

Christ in the Garden of Olives (Bernard), 47
Christmas, 28, 30, 77
Christmas Carol, A (Dickens), 56
Church, 18, 20, 28, 83
Cicadas, 92
Clergyman, 18, 23, 26
Color, 60, 69, 85, 98–100, 105, 108
Complete Letters of Vincent Van Gogh, The, x
Consolation, 107
Conversion, 17
Coolidge Fellows, 11
Cours de Dessin Bargue, 106
Cradle, 28–31, 34, 73, 87
Creation, 4
Creator, 4, 34
Critics, 43, 52, 53, 115
Crows, 116–17, 120
Cry for Mercy, A: Prayers from the Genesee (Nouwen), 11
Cypresses, 92, 100, 102

Daitokuji Zen Monastery, 7, 13, 53
Dandelions, 111
Darkness, 30, 45
Daubigny, Charles-François, 2
Daudet, Alphonse, 93
Daumier, Honoré, 73, 106
Daybreak Community, 5, 9
Death, 10, 23, 39, 55, 64, 84, 90, 98, 132
Degas, Edgar, 7, 113
Delacroix, Eugene, 78, 106, 119, 127
Demond-Breton, Virginie, 106
Depression, 26
Derrida, Jacques, 49, 52
Dickens, Charles, 6, 56, 77, 93
Dickinson, Emily, 65–66, 69–70
Disease, 79
Doré, Gustave, 106
Drawings, 25, 72, 105, 106, 108
Dreams, 4, 23, 48, 75–76, 79–80
Drenthe, 33, 118
Drury, John, 140

Dutch Reformed, 8, 17, 19, 139
Dynamics of Faith (Tillich), 1

Ear, 5, 27, 75
Earth, 52, 99–100, 126, 131
Eckhart, Meister, 3, 4, 129
Ecstasy, 62, 66, 100–101
Eliot, George (Mary Ann Evans), 6, 42, 46, 126
Emotion, 2, 3, 30, 60
England, 19
Epilepsy, 2, 75
Etten, 28
Eternity, 85, 96
Eudes, John, 11, 13
Evangelist, 8, 19, 20, 37, 117, 137
Evening (Millet), 111
Eyes, 4, 22, 31, 69

Failure, 27, 75, 78
Faith, 32
Family, 17, 32, 35, 62, 105
Fire, 58, 112, 116
First Steps (Millet), 105
First Steps (Van Gogh) 105–12
Fishermen, 85–86
Flaubert, Gustave, 6, 78
Flowerpot with Chives (Van Gogh), 115
Fogg Art Museum, xi
Four Hours of the Day, The (Millet), 106
Fox, Matthew, 129
Francis, Saint, 137
Francs, 71, 72, 83
Friendship, 15, 43, 79, 96
Furnishings, 72–73, 79

Gachet, Dr. Paul-Ferdinand, 77
Garden, 72, 102, 105, 113, 124
Gauguin, Paul, 7, 47, 56, 74–75, 86
Gauzi, François, 51
Genesee Diary, The (Nouwen), 11
Geneseo, 12
Ghosts, 49, 55
Ginoux, Madame, 79
Giverny, 7

Index

Glanum, 90
God, 4, 10, 28, 31–32, 34, 44, 58, 96, 112, 128
Gospel, 15, 17, 19, 46, 74, 123
Graetz, H. R., 116
Gratitude, 80, 87
Graveyard, 88
Greek, 7, 18, 137
Guide, spiritual, 5, 10

Hague, The, 30, 118
Halo, 85, 87
Happiness, 22, 45, 132
Harvard, 9
Healing, x, 13, 22, 44
Heart, 22
Heaven, 24, 96–97, 129
Heidegger, Martin, 51
Hiroshige, Ando, 8, 120
Home, 31
Hoogeveen, 118
Hoornik, Clasina Maria, 30
Hope, 62, 98–99
Horses, 111
Hospital, 30, 76, 133, 139
Hugo, Victor, 41
Hulsker, Jan, 117
Humility, 71, 139

Icons, 39, 137
Illness, 6, 76, 79, 89
Illumination, 22
"I'm Nobody! Who Are You?" (Dickinson), 70
Imagination, 56, 69, 99–100
Immorality, 41
Impressionists, 7, 60, 113
Incarnation, 34, 36, 48, 141
Infinity, 93, 95, 97
Innkeeper, 71
Israels, Jozef, 78

Japan, 7, 8, 25, 60, 130
Jesus, 44, 46, 131

Joie de vivre, La (Zola), 40, 44
Journey, 61, 100, 123

Kingdom of God, 33
Knitting Lesson, The (Millet), 111
"Kristians," 47
Kurokawa, Kisho, 24

Laborers, 21, 52, 55, 70, 94
Labors of the Fields, The (Millet), 106
Landscape, 15, 37, 92, 124
Languages, 18
Letters, x, 8, 9, 15, 59, 94
Leys, Henri, 78
Liberation, 56
Light, 1, 28, 30, 45, 95, 132
Literature, 46
Lithographs, 73
London, 18, 109
Longfellow, Henry Wadsworth, 93
Loti, Pierre, 85
Love, 30, 36, 45, 62, 80, 96, 112, 124, 128
Lullabies, 86

Marriage, 30, 32, 88
"Marseillaise," 83
Marseilles, 84
Masterpieces, 6, 26, 77, 108
Meditation, 4, 34, 127
Memento mori, 30
Merton, Thomas, 12
Methodism, 9, 19
Metropolitan Museum of Art, xi, 81, 102
Michelet, Jules, 41, 46, 120
Millet, Jean-François, 30, 36, 78, 92, 94, 105
Millet (Pollock), 95
Miners, 9, 21, 99
Misery, 21, 22
Mission, 60
Missionary, 18, 25
Models, 30, 70, 125
Monastery, 75
Monet, Claude, 7, 54, 113

Money, 19, 25, 32, 75, 84, 122
Monk, 11, 26
Montmartre, 61
Moses, 4, 46, 100
Mountains, 93
Mu-ch'i, 53
Museums, 10, 140
Music, 22, 85, 100, 106
Mystery, ix, 49, 94, 112, 128, 141

National Gallery of Art, 23, 113
Nature, 4, 34, 35, 61, 78, 116, 124, 125
Netherlands, 10, 19
Neunen, 39
New Complete Van Gogh, The (Hulsker), 117
Night, 2, 30, 94, 98
Night Café, 73, 79
Nobody, 22, 71
Northwestern University, 7
"Nothing," 69
Nouwen, Henri, x, 5, 7, 9, 10, 17
Novels, 39, 40

Olive Groves, 48, 78
Orchards, 62, 83
Ordinary, The, 22, 40, 48, 70, 98, 120
"Origin of the Work of Art, The" (Heidegger), 52
Otterlo, xi

Pain, 26, 78–79
Painters, 41, 70, 76
Painting, 60
Painting the Word: Christian Pictures and Their Meanings (Drury), 140
Paintings, 1, 2, 63, 84, 116
Pair of Old Shoes (Van Gogh), 49–57
Paris, 7, 51, 60, 75, 109, 121
Pastor, 8, 28
Paths, 41, 52, 56, 117, 121, 123
Paul, Saint, 55
Pear Tree, 64
Peasant-painter, 92
Peasants, 33, 35, 39, 52, 62, 92, 105, 111, 123

Pêcheur d'Islande (Loti), 85
Pencil, 21, 23, 28, 31
Perfection, 57
Persimmons, 53
Photographs, 105, 106, 108–9, 139
Philosophers, 51, 52, 53
Picasso, Pablo, ix
Pickvance, Ronald, 93
Pieta (Delacroix), 106
Pilgrim, pilgrimage, 24
Pissarro, Camille, 113
Planets, 98
Pleasure, 107–8
Plough and the Harrow, The (Van Gogh), 120
Poets, Poetry, 65, 70, 93, 95–96, 109, 138
Pollock, Griselda, 95
Poor, The, 10, 22, 55, 74, 138
Portraits, 37, 72, 85
 self-portrait, 67, 75
 Self-Portrait as a Buddhist Monk (Van Gogh), 53
Postman, 83
Potato Eaters, The (Van Gogh), 109
Prayer, 86
"Prayer of Columbus" (Whitman), 96
Priesthood, 9
Prints, Japanese, 7, 60, 120
Prophets, 43
Provence, 8, 25, 60

Quesne, Elisabeth du (Vincent's sister), 120

Rappard, Anthon van, 3
"Ray from on High," 32, 87
Reaper, 132
Reaper with Sickle (Millet), 120
Refuge, 74–75
Religion, 7, 98, 129, 131
Rembrandt, 31, 106
Renoir, Pierre Auguste, 113
Renunciation, 45, 78, 141
Revelation, 4, 28, 32
Rhone River, 92

Index

Rijksmuseum Vincent van Gogh, xi, 3, 7, 23
Rilke, Rainer Maria, 137–39
Rodin, Auguste, 137
Rosary, 86
Roulin, Augustine, 81–83
Roulin, Joseph, 83
Rousseau, Pierre Etienne Theodore, 2, 121

Sabots, 52, 110, 123
Sacrament, 62, 105
Sacred, 48
Sacrifice, 28, 45, 78, 101
Sadness, 33, 79
Sailors, 86
Saints, 85, 89
Saint-Exupéry, Antoine de, 57
Saint-Paul-de-Mausole, 90
Saint-Rémy, 13, 47, 90, 77
Salles, The Reverend, 90
Salvation, 22, 131
Sartor Resartus (Carlyle), 55
Sea, 85
Seasons, 73, 116, 131–32
Seeds of Hope: A Henri Nouwen Reader, 10
Sensier, Alfred, 94
Serenity, 35, 79, 89, 98, 135
Sermon, 19, 24, 26, 32, 43
Seurat, Georges Pierre, 102
Shakespeare, William, 6, 77
Shapiro, Meyer, 23, 52, 116
Sheaf, 97
Shepherds, 94
Sheveningen, 117
Sheveningen Beach in Stormy Weather (Van Gogh), 113
Shoemaker, 100
Shoes, 49–52, 109–10
Shorthand, 125
Silvestre, T., 119
Sky, 30, 92–95, 115, 117
Sleep, 67, 69
Solitude, ix, 61, 123, 125
Sower, 97, 106, 108, 132

Sower, The (Millet), 120
Soul, x, 1–5, 126
Souvenir, 76
Spirituality, 5, 10, 128
Spring, 21, 62, 73
Stable, 30, 34
Starry Night (Millet), xx
Starry Night (Van Gogh), 77, 91–92, 95
Stars, 2, 30, 92, 94, 97–98
Storm, 86, 113, 118
Stowe, Harriet Beecher, 6, 46, 77, 126
Studies, 73, 76
Studio, 30, 51, 70, 73, 76
Suffering, 10, 15, 27, 78, 110
Suicide, 79, 133
Sun, 2, 31, 61, 72, 78, 95, 132
Sunflowers, 72, 85, 102
Suzuki, D. T., 12
Symbolic Language of Vincent van Gogh, The (Graetz), 116
Symbolism, 1, 13, 58, 62, 85, 93, 97–99, 116

Tears, 119
Theology, Theologians, ix, 6, 9, 12, 22, 96, 131, 141
Thunderstorm, 118–19
Tillich, Paul, 1
Toulouse-Lautrec, Henri de, 7, 104
Tradition, ix
Transformation, 23, 65, 98, 132
Transiency, 132
Trappists, 14
Trees, 62–63
Triptych, 65, 85
Truth, 42, 98, 126, 129

Uncle Tom's Cabin (Stowe), xx
Union Theological Seminary, 11
Ukiyo-e, 7

Van Gogh (Shapiro), 116
Van Gogh in Saint-Rémy and Auvers (Pickvance), 93
Van Gogh, Theo, ix, 15, 25, 32, 93, 121, 133

Van Gogh, Pastor Theodorus, 28, 39, 140
Van Gogh, Wilhelmina, 46, 77, 83, 95, 126
Van Gogh-Bonger, Johanna, xi, 134, 136
Van Gogh, Vincent
 art, definition, 126
 bedroom, 67–68
 as Buddhist monk, 53
 copying other artists' work, 105–8, 111
 creed, 112
 death, 134
 dog, artist compared to, 41
 ear, 5, 27, 75
 father, 17, 39, 42, 128
 father and mother, 41, 43, 88
 goals, 99
 gravestone, 139
 illness, 6, 75, 107
 and Japanese art, 8
 letters, x, 14–15, 87, 93, 134
 loneliness, 122
 memories, 88, 97
 mission, 20, 26, 43, 47
 oriental art, collection, 53
 paintings, 76, 81
 sales of art, 25–26
 sermon, 24
 sorrow, 119
 studies, 73, 76
 studio, 30–31, 74, 76
 suicide, 116
 Theo, Johanna, and godchild, 90
 women, views regarding, 126
 work, 61, 89
 as "young naturalist," 119
Van Gogh, Vincent the Engineer (nephew), 136

Van Goyen, Jan, 2
Vie et l'oeuvre de J.-F. Millet, La (Sensier), 110
Vincent's Bedroom (Van Gogh), 68–80
Vincent Van Gogh: Art, Life, and Letters (Zurcher), 116
Violence, 116
Virgin Mary, 85–86
Virginia Commonwealth University, 7
Vollmoeller, Mathilde, 136
Voltaire, 78

Weavers, 21
Westhoff, Clara, 137
Wheat, 13, 56, 100, 117, 122, 130
Wheatfield with Crows (Van Gogh), 113–33
"When I Heard the Learn'd Astronomer" (Whitman), 96
Whistler, James Abbott McNeill, 78
Whitman, Walt, 6, 57, 93, 95–97
Wife, 32, 130
Windows, 1, 2, 78, 92, 95, 132
 stained-glass, 64, 72
Winter: The Plain of Chailly (Millet), 120
Women, 31, 88, 127–28
Words, art of, 45
World War II, 3
Writers, 42, 48, 60, 65

Yale Divinity School, 9
Yellow House, The, 71, 73–76

Zen, 53, 120, 131
Zen Painting (Awakawa), 53
Zola, Emile, 6, 40, 43–44, 93, 124, 125
Zouave, 67, 70
Zundert, 25, 88, 139
Zurcher, Bernard, 116

OF RELATED INTEREST BY HENRI NOUWEN

LIFE OF THE BELOVED
Spiritual Living in a Secular World

Over 200,000 copies in print!

Now with Reflection Guide

"One day while walking on Columbus Avenue in New York City, Fred turned to me and said, 'Why don't you write something about the spiritual life for me and my friends?'

"Fred's question became more than the intriguing suggestion of a young New York intellectual. It became the plea that arose on all sides — wherever I was open to hear it. And, in the end, it became for me the most pertinent and the most urgent of all demands: 'Speak to us about God.'"

— *From the Prologue*

When Nouwen was asked by a secular Jewish friend to explain his faith in simple language, he responded with *Life of the Beloved*, which shows that all people, believers and nonbelievers, are beloved by God unconditionally.

HERE AND NOW
Living in the Spirit

In this book of meditations, Nouwen shows in a personal and insightful way that God is much closer than we ordinarily realize.

THE HEART OF HENRI NOUWEN
His Words of Blessing

Edited by Rebecca Laird
and Michael J. Christensen

To commemorate the 70th anniversary of Nouwen's birth, Crossroad has issued this remarkable anthology of the best of Nouwen's writings. Key themes in these writings include a personal relationship with God, suffering, and living for others.

Support your local bookstore or order directly from the publisher at
www.CrossroadPublishing.com

To request a catalog or inquire about quantity orders, please e-mail
sales@CrossroadPublishing.com

www.ingramcontent.com/pod-product-compliance
Lightning Source LLC
Chambersburg PA
CBHW011800170526
45163CB00009B/3125